TELLING TALES

FANTASY AND FEAR IN CONTEMPORARY DESIGN

X

TELLING TALES

FANTASY AND FEAR IN CONTEMPORARY DESIGN

Gareth Williams

V&A Publishing

This book was published to coincide with the exhibition

Telling Tales: Fantasy and Fear in Contemporary Design

At the Victoria and Albert Museum, London
14 July – 18 October 2009

First published by V&A Publishing, 2009
V&A Publishing
Victoria and Albert Museum
South Kensington
London SW7 2RL

Distributed in North America by Harry N. Abrams, Inc., New York

© The Board of Trustees of the Victoria and Albert Museum

The moral right of the author has been asserted.

ISBN 978 1 85177 560 6
Library of Congress Control Number 2008937535
10 9 8 7 6 5 4 3 2 1
2013 2012 2011 2010 2009

A catalogue record for this book is available from the British Library.

Designer: Park Studio

FRONT COVER: *Fig Leaf* wardrobe (see plate 16), 2008
PAGE 6: *Napoléon à Trotinette* console (see plate 27), 2007
PAGE 8: *High Tea Pot* (detail, see plate 66), 2003
PAGE 26–7: *Fig Leaf* wardrobe (detail, see plate 16), 2008
PAGE 28: *Princess* chair (detail, see plate 14), 2004
PAGE 58–9: *Lathe* chair, VIII (detail, see plate 40), 2008
PAGE 60: *Robber Baron* table (detail, see plate 36), 2006
PAGE 90–1: *Aluminium* table (detail, see plate 63), 2007
PAGE 92: *Do You Hear What I Hear*, 2007. Kelly McCallum

Printed in China

V&A Publishing
Victoria and Albert Museum
South Kensington
London SW7 2RL
www.vam.ac.uk

CONTENTS

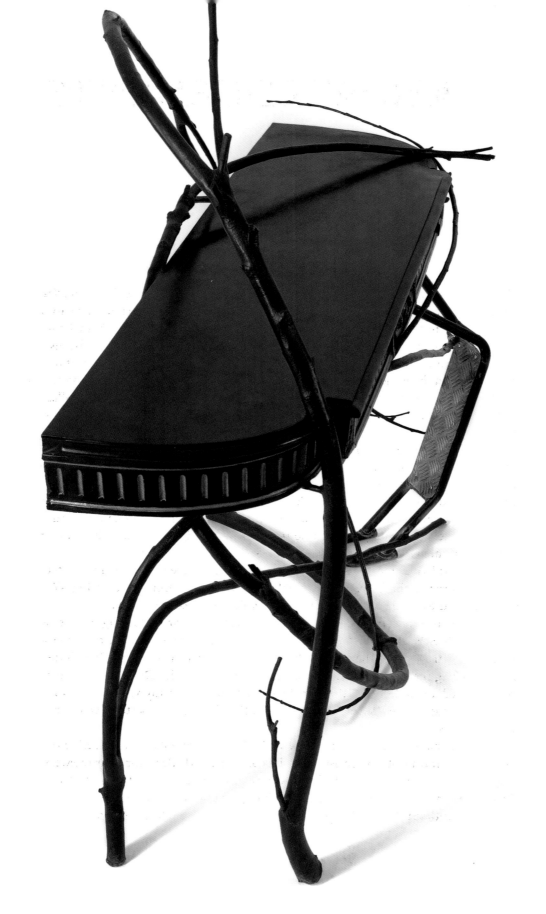

ACKNOWLEDGEMENTS

Thank you to all the 'design artists' whose work inspired me to write this book. You generously shared your projects and answered my incessant, pestering questions. Your works are more eloquent than I am and I hope this book does justice to them. I have enjoyed enthusiastic support from galleries and design specialists who have variously suggested content, checked details, arranged exhibition loans, sourced illustrations, and supported the project with gifts and acquisitions for the permanent collection of the V&A. They are too numerous to list, but special thanks are due to Loic Le Gaillard and Julien Lombrail; David Gill and Francis Sultana; Janice Blackburn; Lina Kanafani; Patrik Perrin and Moët Hennessy.

The V&A Research Department gave me time and space to write the book, as well as the intellectual stimulation and confidence to carry it through. I am most grateful to Christopher Breward for the continuing support of his department. Very great thanks are due to Glenn Adamson, whose intellectual rigour has been inspiring, and whose close reading of my drafts, and pertinent suggestions of material, has transformed the text. Christopher Wilk also read my manuscript and I thank him for his incisive comments and constructive criticisms.

Many thanks are due to Tom Windross, my editor, whose enthusiasm and attention has improved this book immeasurably. I am grateful to Denny Hemming, V&A Publishing, and especially Park Studio for designing this beautiful book.

I am greatly indebted to the V&A Contemporary Team for stewarding the exhibition *Telling Tales*, with particular thanks to Lauren Parker who helped me to hone the idea of the narrative possibilities for 'design art', and Claire Wilcox and Zoe Whitley for organizing the show. Nissen Adams, supported by the V&A Design Department, has designed a wonderful setting for the exhibition, true to my vision of it. Many thanks are due to the V&A Public Affairs and Development Departments for their contributions.

I want to thank all my former colleagues in the Department of Furniture, Textiles and Fashion, most notably Christopher Wilk and Sarah Medlam, for their unswerving support of this project, and of all my previous projects. Many thanks to Hilary French and the Royal College of Art for helping me to finish *Telling Tales*.

Finally, without Richard Sorger I would have no tales to tell. Thank you.

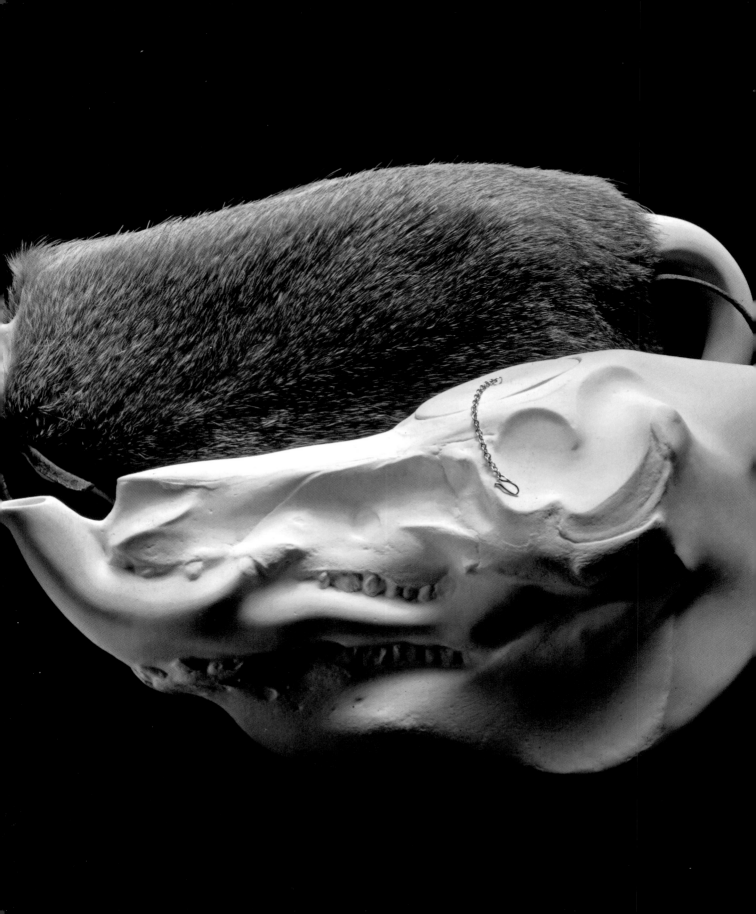

INTRODUCTION

From the start of humankind, we have been trying to understand the world around us. In our search for reasons behind our behaviour, we try to theorize things. Our well-developed brains are not fulfilled by just thinking about essential life actions like eating and breeding. We have many questions, and with questions answers have to follow. The answers become stories; many stories told us how to act and how to look and what to see ... The world around us can enthuse us; the art is to see that.[1]

Jurgen Bey

To 'tell tales' is a phrase wrought with ambiguities, bearing meanings both innocent and deceitful. As children, we are told tales that enthral us with imaginary vistas, but these tales teach us about moral boundaries and social expectations, too. Children also learn the effect of exaggeration and half-truths, and how to avoid blame by telling tales on each other. This behaviour is learned in early childhood but we take it with us into adulthood. Likewise, the designs discussed here display an ambiguous and complex relationship to story-telling and narrative. We are never far from the power of language to shape the imagination, and this book about the design of objects is also a textual narrative. It shows how we can make stories from the things around us, stories that need not be accompanied by clear interpretations. It showcases work by international contemporary designers who make narrative, or tale-telling, an integral part of their finished objects, which often recall fairy stories, history, archetypes, rites of passage or life's rituals. As exemplified by Dutch designer Wieki Somers' *High Tea Pot* (plate 66, detail opposite), a teapot modelled on a pig's skull and enclosed in a water-rat fur cosy, the function of these objects is evocative and symbolic rather than utilitarian. They seem to slip across an arbitrary and invisible line that separates design and art. Indeed, many of these objects are made in small quantities in studios and traded in galleries as artworks, rather than being mass-produced in factories and sold in shops as merchandise. Nevertheless, they retain a connection to function and functionality, and in their materials, techniques and style they remain designed objects. Together, they make us think of something beyond the objects themselves: their narrative character bears associated meanings. Individually and collectively they can tell tales.

How can objects communicate like this? These designers use objects to explore the meaning of past events and our relationship with them by questioning or subverting traditional forms, materials, expectations and historic values. The notion of narrative informs this way of designing. The word 'narrate' comes from the Latin *narrare* ('to tell') and is also akin to the Latin *gnārus* ('knowing', 'acquainted with', 'expert in'). 'Knowing' and 'telling' are inextricably linked, with the implication that what is known is in turn retold. As the cultural anthropologist Victor Turner comments, 'Narrative is, it would seem, rather an appropriate term for a

1. 'World Trade Center', *Buildings of Disaster*, 1995 to present
Boym Partners

reflexive activity which seeks to "know" (even in its ritual aspect, to have *gnōsis* about) antecedent events and the meaning of those events.'[2]

Narratives and stories are primarily oral and linguistic constructions. In his essay 'The Storyteller', Walter Benjamin, the sociological critic, considered how story-telling functions in culture. Benjamin, writing in the early twentieth century, considered that the tragedy of the modern condition was that people had become alienated from the organic quality of story-telling. In its most extreme form, this was typified by the trauma wrought by the inhumanity of war. 'Less and less frequently do we encounter people with the ability to tell a tale properly. More and more often there is embarrassment all around when the wish to hear a story is expressed. It is as if something that seemed inalienable to us, the securest among our possessions, were taken from us: the ability to exchange experiences.'[3] Stories, therefore, link us, but these links can be broken by trauma. In this sense, the work of New York-based Boym Partners entitled *Buildings of Disaster* (plates 1, 2, 71) – miniature replicas of well known buildings that commemorate man-made disasters – are what psychologists

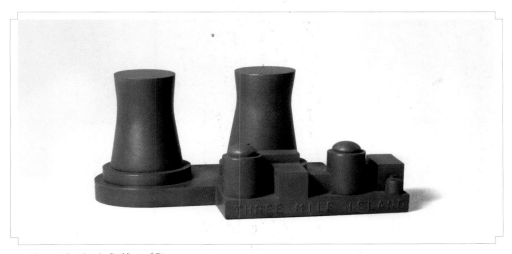

2. 'Three Mile Island', *Buildings of Disaster*, 1995 to present
Boym Partners

might term 'containers', receptacles in which different anxieties can be stored and buried, and which allow us to tell tales once again in the face of terrible events.

Benjamin also draws an analogy between traditional craft skills and the crafting of tales, melding making and telling, the object and the subject:

> The storytelling that thrives for a long time in the milieu of work –
> the rural, the maritime, and the urban – is itself an artisan form of
> communication, as it were. It does not convey the pure essence of the
> thing, like information or a report. It sinks the thing into the life of
> the storyteller, in order to bring it out of him again. Thus the traces of
> the storyteller cling to the story the way the handprints of the potter
> cling to the clay vessel.[4]

The Dutch designer Hella Jongerius knows that the vases she designs tell stories (plates 3, 4). Even though she herself is not the potter, they retain the marks of their making and the shadows of forms from the past.

> Vases were originally meant to be used, of course, but like any useful object a vase has a potential that goes beyond functionality. The story can rise above the object itself ... Useful objects have a rich history. They are saturated with references to specific contexts and specific moments in history. If you refer to that history explicitly, and include all the associations in a new story, then you are communicating something — and it's something about useful objects.[5]

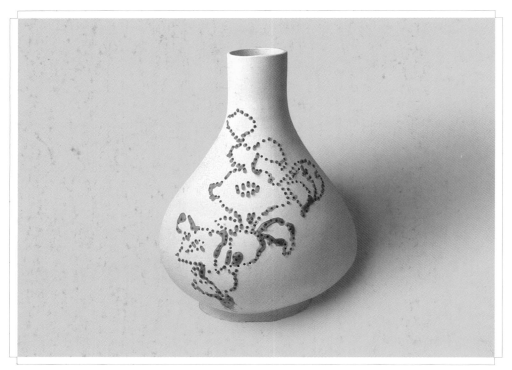

3. *Princess* vase, 2000
Hella Jongerius

Benjamin concludes that story-telling and making objects are aspects of the same activity: 'In fact, one can go on and ask oneself whether the relationship of the story-teller to his material, human life, is not in itself a craftsman's relationship, whether it is not his very task to fashion the raw material of experience, his own and that of others, in a solid, useful and unique way.'[6]

Just as story-telling has been intimately engaged with words and language over time, there is also a long visual narrative history in which stories are represented and symbolized pictorially. Visual tropes and ornamental motifs are loaded signifiers that may be so embedded in cultural terms that we receive them subconsciously. The

tales and myths that underpin Western culture, from creation myths to symbolic representations of the solar cycle, are fixed in our collective psyche. If we accept that we have internalized this cultural heritage (or baggage), then we can accept, with Sigmund Freud, that an exploration of unconscious human experience, through psychoanalysis, can reveal these connections to the past. This theoretical approach has been successfully employed in the consideration of fashion, most notably and thoroughly by the fashion historian Caroline Evans, who writes, 'The processes of psychoanalysis, which uncovers repressed materials, resemble those of archaeology, digging up material that has long remained buried, excavating remnants from the past and making sense of them in the light of the present. In the same way, archaeological fragments of previous historical moments work their way to the surface of

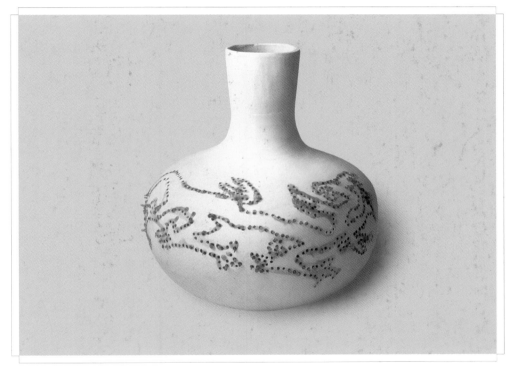

4. *Prince* vase, 2000
Hella Jongerius

contemporary fashion.'⁷ As fashion is but one expression of designed material culture among many, it is reasonable to assume that a similar archaeological approach to other designed objects could be equally as fruitful.

In a very literal way, the Czech ceramic designer Maxim Velcovsky's *Catastrophe* vases (plate 5) look as though they have been disinterred. By evoking a calamity – an earthquake, perhaps – they can act, like the *Buildings of Disaster*, as focal points or containers for our psychological woes. Velcovsky also relishes the mystery of interred objects that resist interpretation.

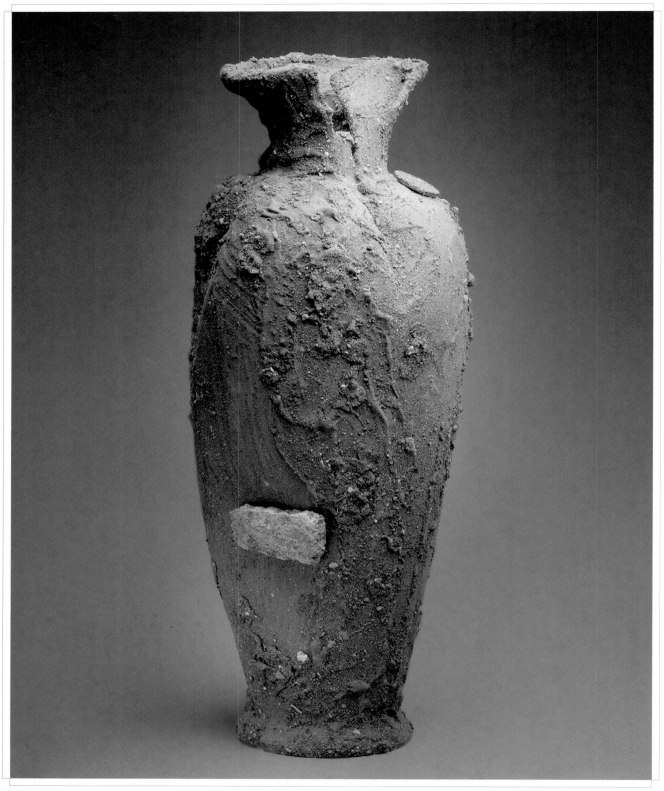

5. *Catastrophe* vase, 2007
Maxim Velcovsky

What fascinates me most about objects found in the ground is their
anonymity. Hidden beneath the dirt of ages, they remain a secret and
this makes them all equal. I am fascinated by their raw beauty before
layers of earth are removed to find the truth about the original shape …
I wanted to free the object of its interpretations derived from its shape,
ornaments or details that can be distinguished on the surface. My
ambition was to create a discovery with a story behind it that will
never be told.[8]

In the study of rhetoric, metonymy is the term used when a word or phrase is used
to represent something it is closely associated with, for example 'Wall Street' represents
the American financial world. It is a helpful notion when considering how an image
or object represents a concept. We will often recognize an object's symbolic purpose
before we see its function. The *Buildings of Disaster*, by concentrating our attention on
particular disasters, are metonymic of disaster itself. A similar concept is that of synec-
doche, where a specific part of something can represent the whole. We recognize,
in the work of Dutch designers Tord Boontje and Jeroen Verhoeven, Boontje's use
of fig leaves (plate 16) to represent the creation myth and Verhoeven's application of
the outline of eighteenth-century furniture forms (plate 42) to represent historical
craftsmanship.

Stories and story-telling rely on such foundations and need structure to work
properly. Common to all tales is the fact that they have a beginning, a middle and an
end. Linguists and historians describe these as inaugural, transitional and terminal
motifs, and they define these as the essential characteristics of a narrative, as opposed
to a chronicle, which is tantamount to a list of chronological events. In a chronicle,
there is no over-arching journey, no protagonist, no denouement and no implied
moral principle at stake. Chronicles may aspire to be narratives but they lack the
crucial mechanism of closure, that is, they simply terminate without the dramatic
episode, or imposition of moral or other meanings, on the story.

Telling Tales is not simply a chronicle of contemporary design. Rather, it aspires to
a narrative structure itself. The objects are grouped in three chapters dependent on
their predominant character, and each chapter is analogous to a different stage in
the development of narrative forms. Together, they also form their own story. The
protagonists are the designers, or perhaps the objects they have designed, and the
tale is itself a metaphor.

In this tale the beginning takes place in a forest glade. Like the Garden of Eden,
it is a place of childlike innocence, symbolized by benign nature. Pastoral bliss and
the innocence of a child's perception of the world are often brought together in fairy
stories and are seen as inter-related or co-dependent. These are stories of enchant-
ment, and these objects are intended to enchant. For the second part of our tale we
come inside, perhaps within the walls of an enchanted castle or palace. The scene
implies that we are no longer innocent, now that we are initiated into adulthood;
in mid-life we may be less concerned with nature and more concerned with world-
liness, decadence and symbols of status and luxury. In short, we revel in our own

immediate existence, but we are reminded that tales can also be parables about our own vanity. The end of our tale contemplates death, and the trappings of material pleasures seem less relevant. Its eschatological, religious character recalls judgement, commemoration, memento mori and reflections on the afterlife.

But before this narrative begins, we need to explore the context within which such a narrative can be located and to establish key relationships. Where artists, craftspeople and designers were once part of the same creative tradition, a schism occurred with the notion of the genius artist. By the twentieth century the tradition had splintered, so that art=individualism, craft=making and design=managing production. It is a truism that the boundaries between these disciplines have since blurred again, and like all truisms this statement is at once irrefutable and yet unsubstantiated. But it may help to use generalizations, at least to begin with, to unravel the relationship of these cousins — art, craft and design. What we can say at the outset is that the mechanisms of the art world, specifically of the art market, have increasingly leeched into the practices of designers, creating a new hybrid dubbed 'design art'. And it is the relationship between contemporary design practice and the art market that is a cause of increasing debate and hyperbole.

Art practice ceased to be in the service of the body civic, religious or politic with the Romantic painters and poets, who internalized creativity. Indeed nineteenth-century culture has been characterized as being preoccupied with inwardness and the self.[9] Henceforth 'fine' art was concerned with the 'creative journey' — the personal exploration and edification — of the artist. If he or she was fortunate, their work would be bought by collectors and patrons, and unsurprisingly novelty, experiment and individuality found favour, as money likes to reflect itself in a flattering guise. This is not to suggest that the internalized and individuated artistic quest was illegitimate, but simply to speak plainly of the mercantile relationship between artists and their patrons. This relationship, based on supply and demand, cannot fail to affect the art-as-product that is created initially for the gratification of the artist, but primarily for consumption by the market. Notwithstanding the history of art connoisseurship that has favoured oil painting above all else and created a sliding scale of 'fine' and 'applied' arts, twentieth-century and contemporary art practice has increasingly favoured 'concept' above 'construct'; the artist's exploration of ideas has become more important than his or her ability physically to construct them. Today, more than ever, the painter's supporting statement is liable to be judged as carefully as the brushwork.

Broadly speaking, this left twentieth-century craft practice to focus on the materiality of the object, its substance and techniques, usually in the sphere of the unique and handmade or the limited edition. Forced into a corner by the voracity of the notion of art-as-individualism-as-concept, brow-beaten craft fetishized the process of making, the creative act least considered (though not entirely neglected) by art. If nothing else, craftspeople could claim to create their own individualized works, even if they were constrained by conventions and dogmas, often of their own making.[10] But little or no space existed for notions of 'creative autonomy' for designers (as opposed to craftspeople) who, in the modern period, became professionalized

into design-managers, juggling the incompatible demands of clients' briefs, market requirements, technological innovation and bottom-line economics.[11]

In recent years several trends have brought the practices of these groups into closer alignment, and the ambiguous term 'design art' stands like a leaky umbrella over them all. Firstly, conceptual, minimal and installation artists responded in their individual ways to the experience of real life by creating works that appeared to mimic or recreate designed objects and environments. Of these, Donald Judd is widely cited as a precursor, but erroneously so, as his furniture and interiors were conceived as actual objects of (relatively limited) utility, not as representations of objects of utility. Judd's own elusive thinking did not help, but maintained the old art/design hierarchy:

> If a chair or a building is not functional, if it appears to be only art, it is ridiculous. The art of a chair is not its resemblance to art, but is partly its visible reasonableness. The art in art is partly the assertion of someone's interest regardless of other considerations. A work of art exists as itself; a chair exists as a chair itself. And the idea of a chair isn't a chair.[12]

His chairs may share common ground visually with his sculpture but their creative concepts are quite different, so there the similarities end. Subsequent artists have created works of art that look like design objects. Jorge Pardo has created works that take on the appearance of interior designs and domestic objects, but which arise from artistic debate rather than design imperatives. One such work, entitled *Project* (2001), reconfigured the reception space and bookshop of New York's Dia Center for the Arts, and was conceived as an installation for a period of two years. Although *Project* looked like an interior makeover of the space, visitors were encouraged to regard it as an autonomous artwork or intervention and were not expected to judge it solely for its effectiveness as a design solution.

At the same time craft practice has revolted against the constraints of a legacy too closely associated with vernacular activities, traditions, technical conventions and even the requirement to make objects of utility. Craft has increasingly asserted 'the concept' as of equal importance to 'the material practice', bravely approaching the practice of making fine art. And the market has responded accordingly, allowing (with some condescension) space for the craft object alongside (but somewhat lower down) 'real' art. There are exceptions that only serve to prove the rule, for example the work of potter Grayson Perry (plate 6) who, by winning the Turner Prize in 2003, conquered the art world.[13]

The so-called 'aestheticization of everyday life', perhaps surprisingly, has been brought about not by artists' quests, or craftmakers' virtuosity, but by designers' relationship with commerce.[14] Design has always been open about its flirtation with capital and has never shirked its responsibility to the hand that feeds it. 'It is no secret that the real world in which the designer functions is not the world of art, but the world of buying and selling,' wrote the designer Paul Rand in 1981. But it is a nuanced relationship: 'Unlike the salesman, however, the designer's over-riding motivation

is art: art in the service of business, art that enhances the quality of life and deepens appreciation of the familiar world.'[15] As Western society has become richer, and culture has become more sophisticated, design has willingly serviced it with ever more products for consumption, seeking, as Rand optimistically put it, to 'enhance the quality of life'. Some may say that designers of aesthetically-oriented consumer goods merely decorate life, and that it is designers of industrial, medical, social, military or civic products and outcomes who actually improve the quality of our lives. Thus the first group – designers of furniture, lighting, objects for the home and so on – has found itself caught in a pincer movement between the constraints of commerce, the ghetto of craft and the individuality of art.

On the one hand, manufacturers selling to the saturated markets of the First World have turned to aesthetics and styling to differentiate consumer goods, in a process

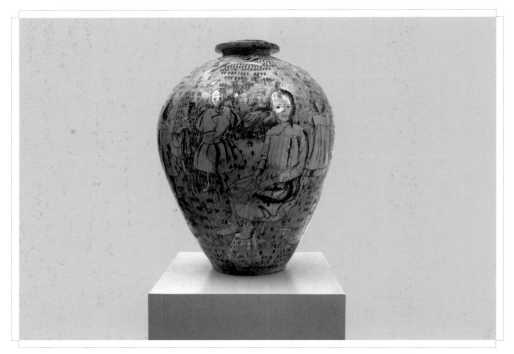

6. *Golden Ghosts,* 2001
Grayson Perry

that American author and columnist Virginia Postrel calls 'the rise of look and feel'.[16] This trend has not been confined to the elite or luxury products. It has seen the democratization of high-end contemporary design across the market, in what may be seen as a trickle-down effect of advanced taste, in much the same way as the high ideals of Modernist designers reached the mass market through product design in the 1930s. Henry Dreyfuss impressed his signature into the moulded plastic vacuum flasks he designed, just as Tord Boontje translated his signature style into affordable Christmas decorations and gift products for the giant American homeware chain Target (plate 7). Conventionally, mass-market products have not necessarily evinced

high-end design values, but this has now changed. IKEA promotes high-end design at low-end prices, achieving both through economies of scale and distribution. Faced with this phenomenon, other design-led manufacturers must match improvements in design quality with concomitant savings in production costs. Constraints like this are familiar ground for designers also trained to be product development managers within teams, but may tax artists or craftmakers who are more used to working in isolation. However, some of the designers discussed here reject the mass-production paradigm altogether. 'Producers make mass productions. We are not producers,' says Job Smeets of Antwerp-based designers Studio Job, who seldom designs for industrial-scale production. 'Designers are hailed when they make thousands of the same thing. But artists are hailed when they make a unique thing. I think the amount of copies has nothing to do with the creative value of the piece.'[17]

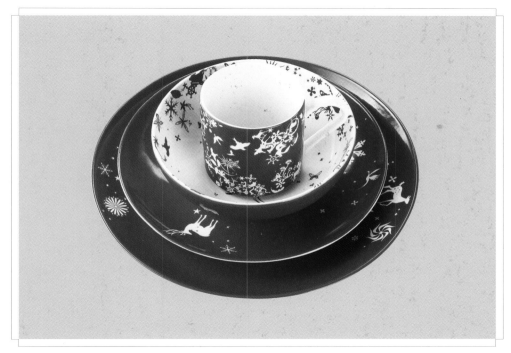

7. Dinner set, 2006
Tord Boontje for Target

On the other hand, democracy, while politically desirable, is not necessarily aesthetically pleasing, and connoisseurship actively rejects populism. Makers' marks, labels and signatures (as well as distinctive signature styles), numbered editions, exotic materials, high quality fabrication and documented provenances in credit-able collections are the ingredients of connoisseurship. This is as true for antiques as it is for modern art or contemporary design. The connoisseur gains expertise and, crucially, is allowed access to rarity. These are the intangible qualities that add quanti-fiable financial value to objects. Since the early 1990s, however, the secondary market, especially for mid-twentieth-century design artefacts, has grown exponentially based

on these values, until a storage unit designed by Charlotte Perriand, or a screen by Eileen Gray, is priced as if it were a fine art object and is traded within the same market as blue-chip artists of the period.

Connoisseurship and rigorous design history also add intellectual value to design objects by applying standards of research and documentation to hitherto overlooked works that are as capable as art (if not more so) of capturing the cultural moment of their inception. They may be more culturally articulate precisely because designers design in tandem with, and in service to, society and culture, rather than making art 'for art's sake'. The cultural theorist Vilém Flusser wrote, 'The word *design* has managed to retain its key position in everyday discourse because we are starting (perhaps rightly) to lose faith in art and technology as sources of value. Because we are starting to wise up to the design behind them.'[18] It was inevitable that objects designed by the likes of Perriand and Gray should become referred to as 'design art' once the model of connoisseurship, borrowed from the art market and art history, was applied to design. The term does little to express the precise role that prototypes, limited or first editions, or experimental forms, play in the history of design, production and consumption of goods, but does much to elevate these objects, in market terms, to that of artistic output, worthy of collecting. More importantly, it positively uncomplicates the notion of design.

The maturing market for mid-twentieth-century design objects fuels demand for newer — even brand new — design objects that conform to the standards demanded by connoisseurs. And here is the rub; as a result some contemporary designers deliberately court elitism and consciously recast themselves as gallery artists, responding to and symbiotically with a network of galleries and auctions focused on design. The work shown in these galleries is free of the constraints of industrial manufacture or the need to appeal to a mass market, and is often cast as 'prototypes' or 'research'.[19] These designers, often well-known names (at least, in the design world), are seeking more autonomy from the design-manager role prescribed for them and more creative freedom than working to industrial briefs will allow. They realize also that art fees are potentially more lucrative than design royalties will ever be. For those designers without the backing of gallerists, small editions of self-initiated projects offer a way to gain autonomy from industry and to produce their own work, giving them access to collectors and the chance to build a media profile. It is no coincidence that they adopt the mechanism of limited editions and the language used to describe collections, borrowed wholesale from the machinations of the art market, even when the bizarre notion of an artist's proof of a chair or lamp seems to stretch the paradigm to breaking point.

The designers who formerly inhabited that space where craft and design intersect were known as designer-makers. Their prophets were Ettore Sottsass and Gaetano Pesce, and Italian designers of the 1970s and 1980s especially prefigured contemporary practice. Alessandro Mendini, the venerable Italian designer and theorist, spectacularly attempted to fuse painterly techniques with historical design in his *Proust* chair (plate 8). Today they have become the new 'design artists', and their prophets are Ron Arad, Marc Newson and Zaha Hadid, whose rank is confirmed by their status

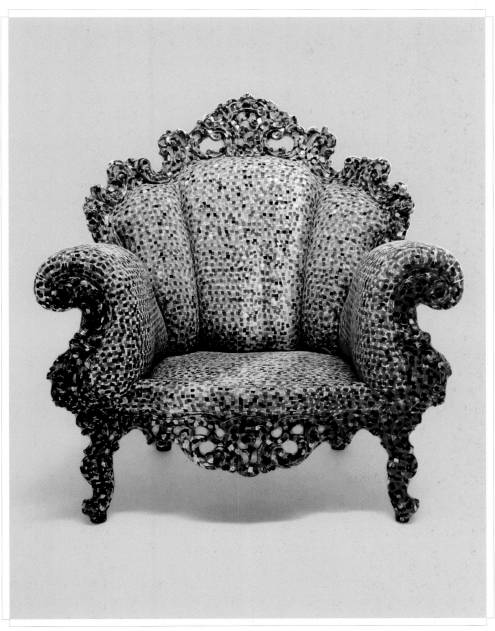

8. *Proust* chair, 1978
Alessandro Mendini

within the art market, and among whose disciples number the brothers Campana and Bouroullec. By specifically producing limited edition works, industrial designers and architects including Ross Lovegrove, Amanda Levete, Barber Osgerby and Patrick Jouin have also engaged with 'design art'. Arad's reputation is built on his innovative, singular, experimental and influential furniture created in small editions over three decades. It embodies all the values demanded by a market built on connoisseurship. Hadid, one of a tiny coterie of 'starchitects' and the winner of the 2004 Pritzker Prize for Architecture, creates works of design that are ostensibly furniture but are actually miniaturized essays in her uncompromising, expressive architectural language. They bear no relation to product design, aside from superficial similarities in material and fabrication, but are most akin to abstract sculpture. Newson's output is more limited

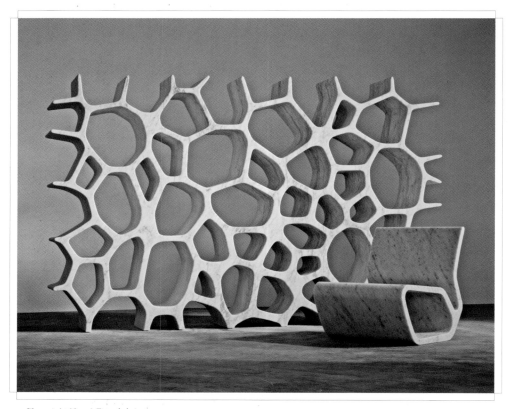

9. *Voronoi* shelf and *Extruded* chair, 2006
Marc Newson, courtesy of Gagosian Gallery

in range and quantity, but is no less visually distinctive (plate 9), and its rarity and panache no doubt contribute to the value ascribed to it by the market. These designers have almost completely disengaged with the design world for their most personal (and collectible) works, preferring to show at art fairs and with art galleries. Newson exhibits with the Gagosian Gallery in New York and Arad with London's Timothy Taylor Gallery, alongside the painters Craigie Aitchison, Bridget Riley and Alex Katz. The contemporary art market has welcomed these designers as, relative to the cost of

art, design objects remain affordable but no less distinctive (those values of connoisseurship appear again). Yet in these early stages of the commercial boom in 'design art', designers of all calibres remain unknown quantities to art collectors.

It is impossible to overlook the support given to the development of 'design art' by museums, which give validation and legitimacy to emerging art trends. New York's MoMA, the Centre Georges Pompidou in Paris, the Vitra Design Museum in Weil am Rhein, the Boijmans van Beuningen Museum in Rotterdam, as well as London's Victoria and Albert Museum and others have all contributed by collecting, displaying and publishing 'design art' objects. These institutions seek critical distance from their subjects and independence from commercial pressures, but inevitably it is difficult to show well-known work and not face criticisms of complicity with the marketplace. The same criticisms are seldom voiced about contemporary art institutions because fine art seems to some to have greater autonomy from commerce than design. However, it is surely the case that both 'design art' and fine art are equally subject to critical assessment as to commercial pressure.

Suddenly almost any object conceived within a spirit of enquiry and experiment can be passed off as 'design art', even if it barely registers in any fundamental test as design (functionality, for example, or appropriate use of resources). Seemingly overnight, and certainly within a few years, an entirely new 'design art' market has arisen as an adjunct to the mainstream market for contemporary art, fed by the rivers of corporate and personal wealth that course through art.[20] Rich collectors have not, generally, invested in design and rarely in craft, although the markets for glass by Dale Chihuly and furniture by Wendell Castle refute this. Launching the first 'design art' sale at Phillips de Pury & Company in New York in 2001, Alexander Payne, the auction house's Worldwide Director of Design, described the category as 'design that aggressively leans towards form and vocalises the boundaries between respected movements'.[21] He acknowledged the tacit demarcation lines between art and design while simultaneously seeking to blur them. Some six years later, in *Art Review*, Mark Rappolt considered 'What is "design art"?' and concluded that it is nearly all about marketing. 'The suggestion ... is that "design art" is about scarcity and the elite end of the market (as opposed, presumably, to the regular kind of product design that is aimed at the masses). It's a type of design that's not designed to work better, but to cater to a rarefied audience.'[22]

'Design art' has continued to prosper. Joshua Holdeman, Christie's Senior Vice President who also heads its Twentieth Century Decorative Arts and Design department, reports that, 'Ten years ago, collectors either had good art and bad objects or good objects and bad art; now the world has changed.' Eighty per cent of his clients for high-end design are also serious art collectors. What is more, he continues, 'I now have twenty collectors spending over $1 million on design annually. Five years ago there was one collector – if that.' The London gallerist David Gill, a pioneer in the field of 'design art' since the 1980s, sees nothing less than 'a new renaissance in collecting'.[23] Events in Milan, London and Basel, often orbiting the behemoth contemporary art fairs, promote 'design art' to a receptive market, perhaps jaded by contemporary art but hungry for novelty.

Aestheticized design, therefore, is pulled upward toward the art market and down and out towards the mass market. In the face of such forces, what spaces are left for innovative designers who may not feel sympathy with industrial design, popular taste or the glitter of the art world? Must they retreat into the ghetto lately vacated by craft, where creative autonomy is tolerated because few other market pressures come to bear? This seems unlikely as designers today are trained to think and act with the ingenuity and individuality of artists and, having broken free of the design-manager shackles imposed upon them, are unwilling to fetter themselves. But since they seldom control the production of their artefacts, designers have even fewer expressive outlets than craftmakers. The leading design schools, most notably Design Academy Eindhoven in Holland and London's Royal College of Art and Central Saint Martins (all of which have alumni in this book), create highly individuated graduates, more drawn to creating statements in art galleries than corporate work. At Eindhoven, students can study for a Conceptual Design in Context Masters degree, suggesting that narrative, along with other ideas-based design approaches, are positively encouraged. So we see another variant of 'design artists' emerging, that of the 'manifesto designers', who create objects embedded with complicated content, like an argument, proposition or thesis. Manifestos have ambitious aims but can divide opinion. This description fits most of these works, giving weight to claims for its significance.[24]

Postmodern design and the objects discussed here share a relationship that is key. Mendini's *Proust* chair epitomizes the high Postmodern design that flourished in the late 1970s and 1980s. Postmodernism plundered the histories of art and architecture and argued the equal validity of high and low culture, past and present, using irony to pass comment on a world after Modernism that was dominated by signs and surfaces. Irony relies on discordance between intention and effect, and is generally a literary or dramatic device, but it is widely used by designers, too. For ironic design to succeed, the viewer must have a pre-existing notion of how to interpret a stylistic device, material or technique, which is then subverted by the way in which it is delivered. To take the example of the *Proust* chair, our understanding of the two-dimensional painterly surface is circumvented by its delivery as a three-dimensional upholstered form, while the formality of the rococo shape is at odds with the pointillist decoration applied to it. In short, things are neither what they immediately seem to be, nor do they seem as they ought to be. In many respects much of the work included in this book seems to embody Postmodern thinking, and relies on similar strategies of exaggeration and parody. Yet in a significant way these contemporary designs differ conceptually from the Postmodern designs of the Italian *maestri* or American architects like Michael Graves during the 1980s. Whereas the previous generation sought to imbue design with an invigorated symbolic quality, their work seldom engaged the emotions, remaining as cool, intellectual exercises. The same is not true of the designers discussed here, whose work, while symbolic, is much more emotionally hot and tackles universal psychological truths.[25]

'Design art' can be defined in a number of ways, depending on your point of view. It can be seen as a mode of practice within a larger discourse on contemporary art

practice; a creature of the arts and antiques market, based on connoisseurship and market demand; or the creative outpouring of a new generation of designers schooled in the discipline of design-management but with the creative freedom of artists. Perhaps the third definition is the most interesting and significant. Just as in much contemporary art and some craft, critical and conceptual designers subordinate materiality and functionality to symbolism and emotional resonance. Design may even have an advantage here because it is grounded in common experience, even if it is expressed uncommonly. Among the designers represented here, London-based Dunne and Raby represent the paradigm of an intellectualized, critical, non-commercial, de-materialized and virtually de-aestheticized alternative to conventional design practice, a blast of fresh air blowing through the stagnant debates about the nature of design, art and craft.

Critical and conceptual design practice is as diverse and individuated as could possibly be hoped for by a market that craves singularity and rarity. Yet there are common themes and shared concerns running through much of the work, which has led to what we might describe as a Dutch inflection in international design today. The root of this inflection is a response to historical precedents and paradigms, both ironic and celebratory. Indeed, the work picks up and retells the narratives and stories, those cultural imperatives and threads that existed in design before the schism of twentieth-century Modernism, with its rejection of history and ornament, broke them. Does this make work by Hella Jongerius and Jurgen Bey, for example, reactionary and conservative? Far from it, as their responses to the past are never slavish or ill-thought reproductions; rather they are filtered through their awareness of the requirements of the present.

Telling Tales, therefore, explores a certain manner of designing-with-narrative, embodied by designers like Bey and Jongerius, but also Dunne and Raby, Boym Partners, Studio Job, Marcel Wanders, and a host of others. Most of them are regarded as 'gallery designers' or 'design artists' at least some of the time. All their works are unique, or produced in limited quantities and editions. By listening to the tales their objects tell, we can often hear echoes of the past and of universal stories.

THE FOREST GLADE

'No', she said, 'we must not talk of the things we find in the heart of the forest. They are all secrets. If they were not secrets, we would have heard of them before.'[1]

Angela Carter

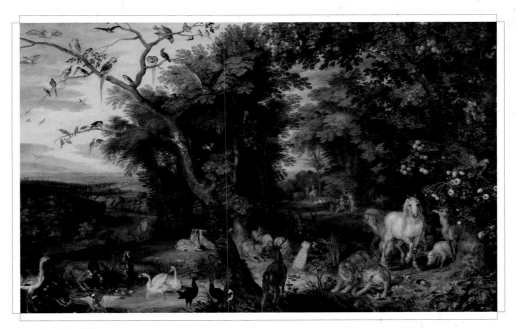

10. *The Garden of Eden, c.*1600
Jan Breughel the Elder (1568–1625)

Against all the evidence of an industrialized, globalized, high-tech world (or perhaps because of it) some designers retreat to pastoral idylls of fairy tales, myths and nature. In so doing they return us to our most primitive state. No doubt their designs are escapist, even naïve, and can be quite deliberately childlike. Their faux-rustic objects look as though they belong in a forest glade straight from classical mythology or northern European fairy tales, or perhaps even the biblical Garden of Eden (plate 10). But these designers are deadly serious about wanting to disengage us from ordinary life and reconnect us to a state of innocence and wonder.

The earliest narratives were creation myths and metaphors for rites of passage; stories in which the action often takes place in glades such as this. As Harold Bayley

wrote in *The Lost Language of Symbolism* (1912), 'Little or no distinction can be drawn between classic myth and popular fairy-tale: myth was obviously once fairy-tale, and what is often supposed to be mere fairy-tale proves in many instances to be unsuspected theology.'[2] What is common to all these forms of narrative is a reliance on metaphor, allegory and the universal. Bayley determined that about half of all fairy stories derive from myths around the solar cycle, in which characters fall from grace and endure peril before they are 're-born' in glory, symbolic of the evening setting and morning rising of the sun. A similar pattern shapes the numerous versions of the Cinderella story that occur across history and in different cultures, in which a young girl endures hardship and abuse before marrying her prince.[3] Cinderella's journey is

11. *Dear God, thank you for protecting us*, 2008
Barnaby Barford

an analogy for the solar cycle, but it could also be interpreted as an analogy for the path from childhood to maturity. Such rites of passage are a feature of many myths and, later, folk stories and fairy tales. This is the territory of contemporary artists such as Kiki Smith (who has created a body of work called *Telling Tales*, in which she casts herself in the role of the witch) and the author Angela Carter. Barnaby Barford, whose practice straddles art and design, frequently refers to these themes. His assemblages of modified found figurines rely on our recognition of familiar

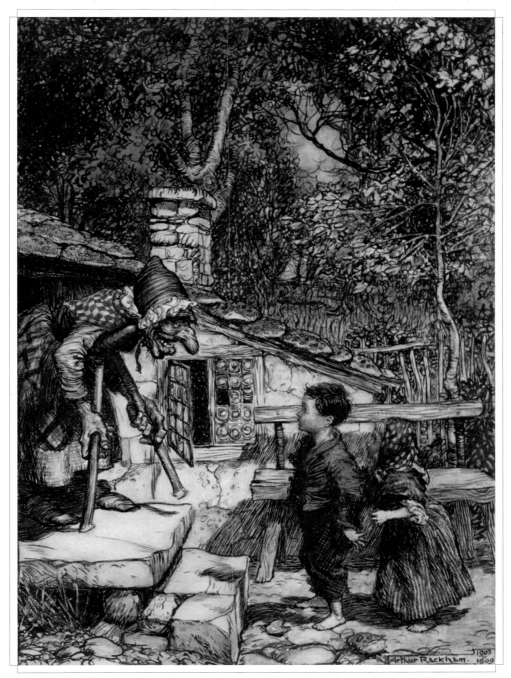

12. *Hansel and Gretel* from *Fairy Tales of the Brothers Grimm* (1909 edition)
Arthur Rackham (1867–1939)

characters playing recognizable roles, drawn from a repertoire of fairy stories and nursery rhymes and often interpreted through the lens of popular culture. Typical is *Dear God, thank you for protecting us* (plate 11), a visual pun on to 'prey' and to 'pray', which depicts a Disneyesque wolf stalking a cloyingly innocent little girl.

Bayley draws analogies between fairy tales and theology, and gives a convincing reading of the Old Testament Song of Solomon as a version of Cinderella, and the ascension of Christ as a solar cycle story. We can make other comparisons: in the Bible Eve eats the apple, simultaneously gains knowledge and loses innocence, and is cast from Paradise, but when Snow White eats the apple she is poisoned. Seductions and deceptions are associated with gaining knowledge, so Little Red Riding Hood is almost seduced by the wolf and Hansel and Gretel are hoodwinked by the witch (plate 12). Each of these tales, and countless others, appeals to us because they are a form of communal communication about the cycle of life and the human condition operating at fundamental, pre-linguistic psychological levels. Or as Jack Zipes puts it, in his survey of classical fairy tales *When Dreams Came True* (1999), 'tales are marks that leave traces of the human struggle for immortality. Tales are human marks invested with desire.'[4]

Today, fairy tales are perceived as children's literature, but this was not always the case. Zipes notes that the term *conte de fée* ('fairy tale') was coined by French writers of the seventeenth century, and what had been a purely oral tradition gradually coalesced into a literary convention as literacy increased, first in Italy and during the late seventeenth century, in France.[5] Marina Warner's study *From the Beast to the Blonde* (1994) focuses on the tellers of fairy tales. She writes that it was the publication of Charles Perrault's *Histoires ou contes du temps passé* in 1697 that inaugurated fairy tales as a literary form for children and contains some of the best known and best loved fairy tales in the world, including Cinderella, Little Red Riding Hood and Sleeping Beauty. But both she and Zipes also note that inventing and recounting fairy tales gave political and social voices to constrained groups, such as women at the French royal court, a process that had nothing to do with childhood. The Abbé Fénelon, theologian and tutor to the Dauphin, who wrote didactic fairy tales to make his lessons more palatable to the young prince, wrote that even the most serious men enjoy 'fables – even those which are like fairy stories ... We willingly become children again.'[6] *Children's and Household Tales* by the Grimm brothers appeared in German between 1812 and 1857. Their work had a nationalist and anthropological intent alongside literary ambition. The publication of their tales overlapped with Hans Christian Andersen's collection that appeared a little later between 1835 and 1872. These and other lesser-known collections of stories in the mid-nineteenth century appealed to a broad audience of adults and children alike. Whether or not fairy tales – or these designs – are innocent or infantile depends on your personal point of view. What can be said is that a generation of designers are exploring the universal truths underlying fairy tales in a new way.

Nadja Swarovski, Vice President of International Communications for her family crystal firm, says of Tord Boontje, 'He awakens the child within us, that's the power of his products. You feel comforted by them.'[7] While we may expect such enthusiasm for Boontje's work from one of his leading clients, the important point she identifies

is the strong attraction of childhood associations. More than any designer work-ing today, Boontje is inspired by fairy stories and willingly submits to the allure of the imagination. It was the birth of his daughter, Evie, to his wife artist Emma Woffenden in 2000 that prompted a radical shift of gear for Boontje. From design-ing brutally raw furniture from salvaged or poor materials, seemingly overnight he reintroduced pattern and fantasy into contemporary design, inspired by northern European folklore and naturalism. His first design, a foil lampshade patterned with foliage and initially intended for Evie's nursery, became a best-seller for Habitat. Boontje

13. *Witch* chair, 2004
Tord Boontje

continued to produce elaborate foliage designs, most commonly in silhouette, which were then laser-cut from metal foil, paper or fabric and used to create garlanded lampshades and upholstery or liana-like wall hangings. In 2002 Boontje reinvented the form of the chandelier with *Blossom*, a semi-figurative cherry bough in full flower, recreated with Swarovski crystals. Expanded in scale, and cut from sheet steel, Boontje's fronds then became the structure of the furniture itself with the *Petit Jardin*

chair (plate 15) and bench, made in a small edition of eight. This design, which originated as a cardboard model, is assembled by hand. It was the first studio piece to be completed after Tord, Emma and Evie emigrated from London to rural France, so it was fitting to give it a French name.

In collaboration with the fashion designer Alexander McQueen, Boontje reimagined his chairs as fairy-princess characters, clothed in glamorous evening gowns like Cinderella at the ball. He balanced these fantasy creations with a darker feel, designing a chair clad in black leather scales, called *Witch* (2004), for Italian furniture manufacturer Moroso (plate 13). His installations, made for Moroso and Swarovski, were like entering fairyland, in part inspired by his childhood visits to his maternal grandmother in rural Sweden. Throughout all these projects Boontje succeeds in suspending his adult cynicism – and ours – to take us into imaginary

14. *Princess* chair, 2004
Tord Boontje

landscapes, landscapes that at the time seemed thoroughly at odds with the prevailing minimalist design aesthetic (plate 14).

Tord Boontje's latest furniture is more ambitious, exploiting traditional craft expertise rather than industrial materials and techniques. It has been made by Meta, a British brand launched by Mallett's, a major antique dealer founded in London in 1865 and specializing in eighteenth-century furniture. Meta's artistic directors, Louise-Anne Comeau and Geoffrey Monge, who act as consultants to such luxury brands as Swarovski and Louis Vuitton, asked well-known designers to use luxurious materials and skilled craftsmanship to produce exclusive, high quality furniture and products.

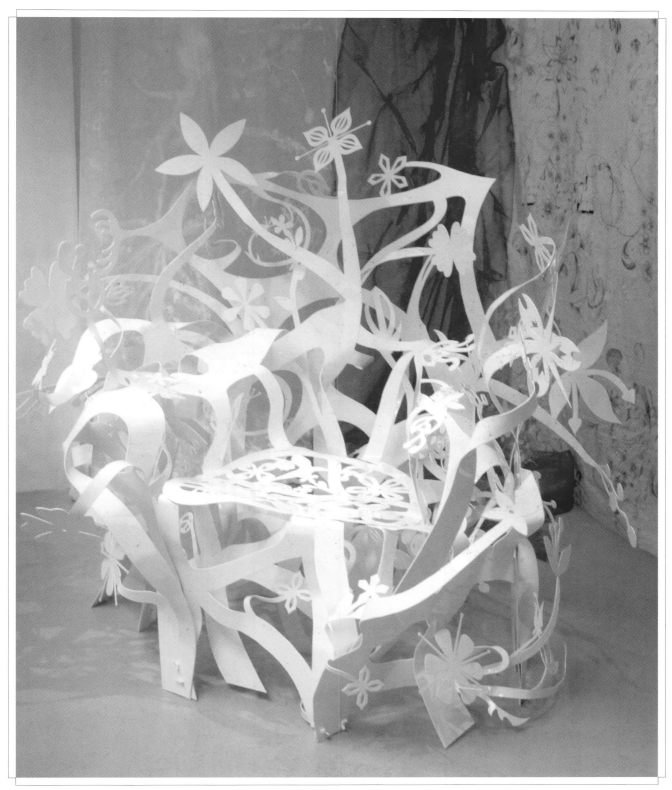

15. *Petit Jardin* chair, 2006
Tord Boontje

Boontje's spectacular *Fig Leaf* wardrobe of 2008 (plate 16) took 18 months to develop and has doors formed from 616 naturalistically rendered, hand-enamelled, copper fig leaves on bronze armatures. The leaves were made by some of the last remaining enamellers in the British Midlands, the historic home of the luxury metal trades. They were made in ten sizes, modelled and coloured to match actual leaves supplied by the designer. The enamelling is so labour intensive – it takes six hours to paint each side of each leaf – that Meta predicted it could only produce three such wardrobes a year. The superstructure to support the leaves was made in Angers, western France, while the 'tree' inside the wardrobe was sculpted in lime wood by Patrick Blanchard in Paris and then cast in bronze. Behind the tree, a silk 'sky' was specially woven by the Gainsborough Silk Weaving Company in Suffolk, and the entire object was assembled in Cambridge.

The first Meta collection of 11 works was launched during the Milan Furniture Fair in 2008, and alongside Boontje's work it also included designs by Matali Crasset, Barber Osgerby, Wales and Wales, and the New York practice Asymptote. In the mercantile context of the Fair, generally devoted to sales of industrially-made furniture, the wardrobe seemed out of place. Its avowed excessiveness and relative uselessness even seemed offensive to some observers, who expected to see more utilitarian, if still high style, objects. In fact, these are the very characteristics that could qualify it as 'design art'. Previously, collectible furniture produced as prototypes and small editions had been valued precisely because of its implicit potential for mass production, or its commentary on such processes (works by Marc Newson might fall into this category), but here was an object that shunned the possibility of reaching a broad market through modern mass-production techniques. It demonstrated a renewed confidence by manufacturer and designer alike to make autonomous design objects. The works from the Meta collection will not be made in limited editions; rather their exclusivity will be preserved by the craftspeople's ability to produce only a few examples every year (and by the concomitantly high prices that such work commands).

In many ways the *Fig Leaf* wardrobe defeats critics of 'design art', who fear that design's principal purpose, functionality, has been usurped in favour of eye-catching visual appeal. The *Fig Leaf* represents a virtuoso handling of materials and techniques in the service of aesthetic excess, nominally functioning as a wardrobe but actually functioning as a vehicle for Boontje's design vocabulary, and as an object of desire, contemplation and investment. Meta itself likens it to the tradition of fantasy furniture, intended to show off craftspeople's skills and attract wealthy patrons, and particularly compares it to the work of the eminent seventeenth-century French ébéniste André-Charles Boulle. The *Fig Leaf* is 'decorative art' in a sense that would have been understood until the early twentieth century, but the meaning of which has been debased and diluted by the doctrines of Modernism. Key to this interpretation is Boontje's use of naturalistic decoration, but he also makes symbolic associations. The idea of Paradise is represented in the Qur'an as a verdant garden and in the biblical book of Genesis as the Garden of Eden. Boontje regards the fig as a symbol of both fertility (associating it with the oases that were possibly the models for these images of Paradise) and loss of innocence (Adam and Eve are clothed only in fig leaves

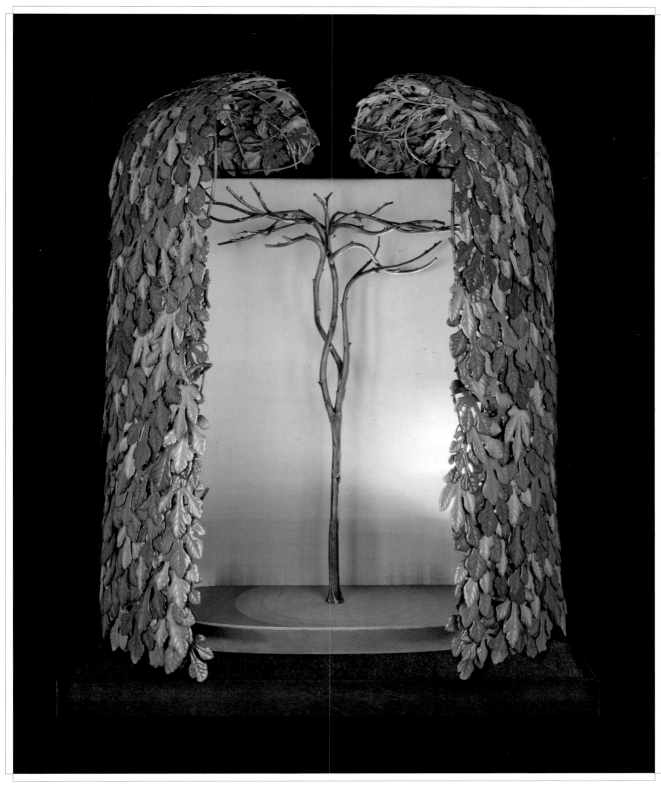

16. *Fig Leaf* wardrobe, 2008
Tord Boontje

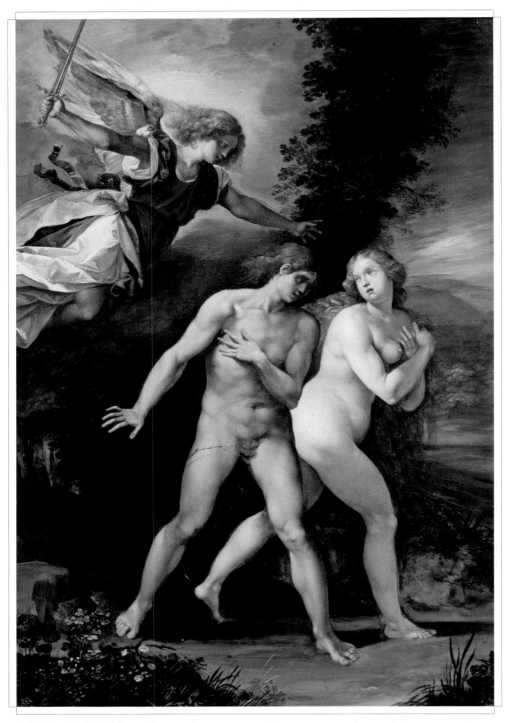

17. *The Expulsion from Paradise*, 1600–40
Giuseppe Cesari, also known as Cavaliere d'Arpino (1568–1640)

as they are expelled from Paradise, plate 17). The fig leaf cast in about 1857 to cover the nakedness of a plaster cast of Michelangelo's *David* (now in the Victoria and Albert Museum), and so spare Queen Victoria's blushes, fittingly exemplified how, from the 1830s, the stylized foliage found in late Neoclassical design became increasingly naturalistic (plate 18). The wardrobe is dressed on the outside with fig leaves but on the inside represents nakedness in the form of leafless cast bronze boughs. This, for Boontje, amounts to a 'reminder to be natural' by reconnecting us with powerful natural metaphors.[8] There is, of course, a delightful irony in clothing the wardrobe by hanging clothes in it, and in so doing becoming naked oneself.

Naturalistic realism in contemporary design has its roots in the decorated furniture traditions of mid-nineteenth-century Britain, exemplified by the so-called Warwick School of Carvers and, in Newcastle, by Gerrard Robinson. Robinson's major work was a series of sideboards, which he carved with scenes depicting narratives from English culture and history. One example featured a depiction of the

18. Fig Leaf for *David*, c.1857
Possibly D. Brucciani & Co. (active around 1820–1910)

Ballad of Chevy Chase; others were carved with scenes from Shakespeare (plate 20) and Daniel Defoe's *Robinson Crusoe* (both were shown at the International Exhibition in London, 1862). Evidently Robinson was a maker of showpieces, and his sideboards were vehicles for ebullient, virtuoso, carved decoration, comparable in role and impact with Boontje's wardrobe.[9] For both, naturalism ensures their work remains accessible and comprehensible because their references and allusions are universally readable.

Nineteenth-century naturalism was superseded by fashionable styles inspired by Oriental design and the relatively puritan Arts and Crafts movement, but a strain of naturalism persisted in popular design into the twentieth century. Despite the onslaught of Modernism, most of whose theorists despaired of decoration ('baubles, charming entertainment for a savage', as Le Corbusier defined it),[10]

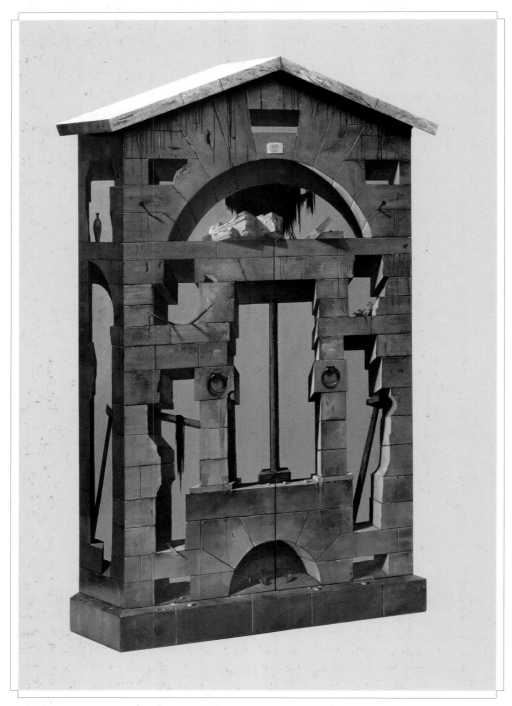

19. Wardrobe, 1939
Painted by Eugene Berman (1899–1972)

naturalistic decoration persisted in Surrealist art and design, presumably for the disjunctive effect produced by seemingly 'real' objects encountered out of context (a lobster as a telephone, for example). Indeed, the doors of Boontje's wardrobe open to reveal a surreal landscape worthy of Rene Magritte.[11] Its colours, forms and composition also suggest the theatrical hyper-reality of Russian-born designer Eugene Berman in his wardrobe of 1939 (plate 19). None of these examples is explicitly referred to by Boontje but collectively they give historic context to the *Fig Leaf* wardrobe, which becomes part of a continuum of expensive and highly decorated, symbolic furniture produced as one-off display pieces.

Like Boontje, there is a deliberate setting aside of maturity in favour of childlike wonder in the work of Rotterdam-based Jurgen Bey. He creates objects in much the same way that children build castles and camps from furniture and blankets. He

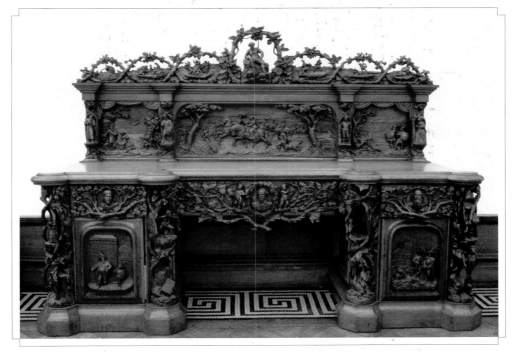

20. 'Shakespeare' sideboard, 1862
Gerrard Robinson (1834–1891)

makes it sound entirely innocent to create such places but in reality there is a transgressive aspect to a child making a bivouac. It is an assertion of his or her autonomy and separation from the world of adults. The bivouac becomes a private place beyond the control of the mores and conventions of good behaviour; a place where imagination and experiment can prosper, stories can be enacted and, as Marina Warner suggests, moral boundaries can be learned. Warner considers the various meanings of the verb 'to wonder' as a key to understanding fairy tales. Meaning both 'a state of marvelling' and 'an active desire to know', wondering about the content of fairy tales connects taking pleasure in the fantastic with curiosity about the real. She concludes

that 'the dimension of wonder creates a huge theatre of possibility in the stories: anything can happen. This very boundlessness serves the moral purpose of the tales which is precisely to teach where boundaries lie.'[12]

Bey makes things seem extraordinary by changing the way we perceive them. 'As a designer, I feel like an explorer travelling the world out of curiosity, or being sent on a mission, investigating, asking questions, and making connections. And I always come back with stories – stories told with design because that is my language.'[13] Many of his best known designs incorporate found objects that he recycles, not only because of ecological imperatives (though these are present in his work) but also because they resonate with, and connect to, history. His *Linen-Cupboard-House* of 2002 (plate 21), also known as the 'Garden House', is intended to be a small guest room. 'My Garden House is made of all kinds of odds and ends jumbled up in a different place from where you'd normally find them,' explains Bey. 'Still, they speak a recognizable language. They're just in a different combination from what you'd usually see, so a new world is created consisting of things we recognize. Building sheds, sleeping under the starry sky or in a solid bed – everyone knows what you're talking about when you speak of these things, and they represent a certain feeling.'[14] Bey imagined a narrative for the creation of the *Linen-Cupboard-House* in which 'a sleeping old useless linen-cupboard in the loft wanted to be a little sleeping-house. Together with old blankets, forgotten clean sheets and a table they became a "Linnenkasthuis".'[15]

Not only does the *Linen-Cupboard-House* connect to the experience we all share as children, it also recreates the kind of romanticized cabin of fairytale and myth, typified by the gingerbread house in the tale of Hansel and Gretel. Far from being the site of innocent pleasure that it purports to be, it turns out to be the home of a witch. Arthur Rackham, the early-twentieth-century children's book illustrator, depicted it as the archetypal little cottage, set deep in the forest (plate 12). In other tales, the sanctuary offered by the cottages of both the Three Bears and Little Red Riding Hood's grandmother has been defiled by intruders with less than innocent intentions. The sweetness of the fairy-tale references in Bey's work, as with Boontje and, indeed, Rackham, is tempered by darkness derived from loss of innocence.

The figure of the woodcutter (who has already made an appearance as the father of the errant Hansel and Gretel) is evoked in one of Bey's most striking works, the *Tree Trunk* bench (plate 22). It is notable for many reasons. Firstly, it returns us to the most elemental notion of comfort and domesticity, the temporary encampment of our hunter-gatherer forebears, where a fallen trunk may have offered a platform to sit on or lean against. Quite naturally, such trunks have hollows and recesses that we find more or less formed to fit the human body (something many of us discovered when, as children, we climbed trees). The bench, therefore, represents not only humankind's first engagement with nature, but also our first steps towards moderating nature to suit our own ends (and the rest, as they say, is history). Secondly, the hewn tree trunk, in its unmoderated state, bark and all, stands for the raw material that forms the basis of all conventional furniture, so the bench represents the origins of the history of furniture itself. It is the simplest, and therefore arguably the most effective, use of wood to create furniture.

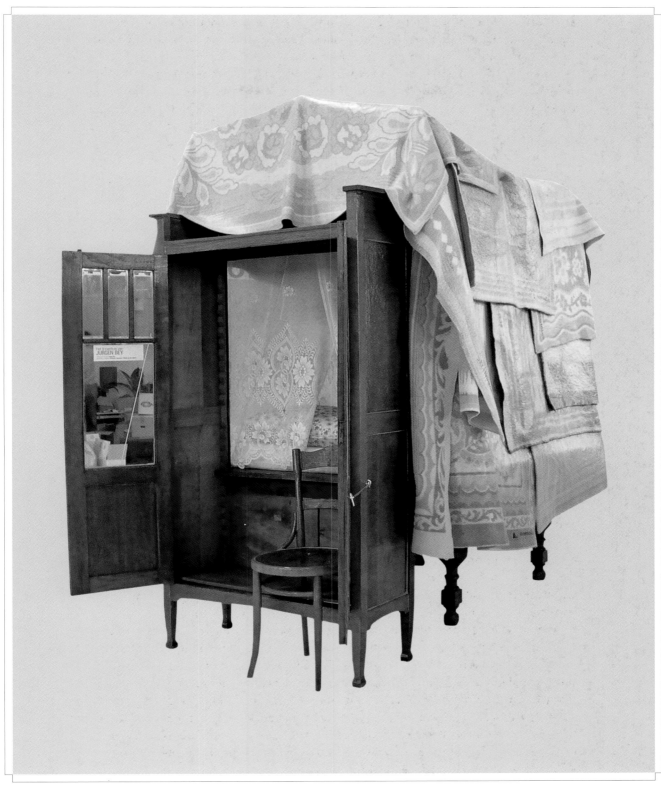

21. *Linen-Cupboard-House* ('Linnenkasthuis'), 2002
Jurgen Bey

But Bey has not merely re-designated a fallen tree as a functional bench. He has intervened physically by inserting Victorian chair backs into it. These dainty and stylish chair backs are used as archetypes and represent the politeness of the bourgeois parlour. Ironically, they have not been taken from genuine nineteenth-century chairs at all, but are bronze casts of contemporary copies. Their inauthenticity is in stark contrast to the integrity of the log on which they sit and conventional notions of taste and behaviour are rudely confronted and questioned by this abrupt juxtaposition. Bey is not the first designer to exploit the pastoral resonance of timber in its natural state. Eighteenth-century grotto furniture replicated rampant nature and, more recently, the 1985 *Domestic Animals* series by Italian Postmodernist designer Andrea Branzi pairs raw branches with geometric, polished furniture elements, drawing attention to the contrast between that which is natural and that which is refined.

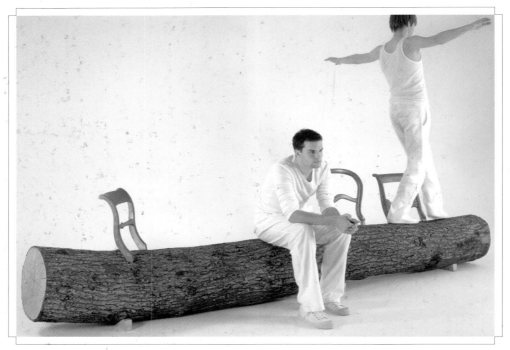

22. *Tree Trunk* bench, 1999
Jurgen Bey

Bey originally conceived the *Tree Trunk* bench in 1999 for an outdoor setting in the park of Oranienbaum, a Baroque palace southwest of Berlin, and described it as 'an interaction between culture and nature'.[16] The park itself is a cultivated landscape, with constructed streams and imaginative recreations of Chinese gardens, in which nature is treated as a souvenir. However, the bench is more typically encountered in far more modern, urban and sophisticated surroundings, such as the lobby bar of the Hudson Hotel in New York. With each relocation, it succeeds in evoking distant and not-so-distant pasts, and demonstrates how the paradigm of 'the natural' is inevitably co-opted.

23. *Table #1*, 2001
Patrik Fredrikson/Fredrikson Stallard

24. 'Anoushka', *Cow* bench series, 2004
Julia Lohmann

The role of the woodcutter is again suggested by *Table #1*, designed by Patrik Fredrikson (2001), which appears to be simply a bundle of logs lashed together (plate 23).[17] The logs are untreated birch, complete with peeling bark, from the forests of Fredrikson's native Sweden. But they are not what they seem. The cut surface of each log is polished and smooth, and perfectly aligned to create a practical table surface. The logs also appear to float as the whole group is raised from the floor on a hidden metal armature. By these devices — immaculate finish and meticulous presentation — the 'naturalness' of the logs is both emphasized and contradicted. As with Bey's *Tree Trunk* bench, Fredrikson's *Table #1* treats notions of nature and simplicity with irony. The intent is earnest (Fredrikson wants us to regard the table as merely a bundle of logs), yet doubts its own earnestness (it is clearly more than just raw timber). The table is an example of self-conscious inauthenticity, used to critique something beyond itself, in this case, our sophisticated expectations of pastoral simplicity.

The pastoral theme is continued with the image of a ruminating cow, the subject of Julia Lohmann's series of benches (plate 24). Each one is made from a single hide, which the German-born, London-based designer fits over a carved, expanded-foam core, made to fill the hide precisely. The *Cow* benches, which were made in a small herd of 30, are individually named — 'Rosel', 'Belinda', 'Else', 'Carla' and others — and Lohmann supplies them with their own passports. She draws our attention to the anonymous use of most leather by reconnecting us in a very visceral way with the body, character and condition of particular animals. She wants the benches to act as memento mori for the cows that died to make the leather from which they them-selves are made, eliminating the distance between the animal origins of leather and its utilization by us. The cows appear recumbent, and if they still had heads it would be easy to imagine them chewing the cud. Lohmann's benches could be abhorrent — her engagement with the physicality of animals and flesh is often harsher and more shocking — but here she diffuses the risk by infusing her design with humour and gentleness. The comic quality of her domesticated bench (albeit tanned and decapi-tated) connects it to a state of innocence, evoked by some of the other designs grouped here.

The Dutch designer Maarten Baas uses comic forms, too, but his furniture is more serious than its humorous appearance may at first have us believe. His *Clay* furniture was constructed by hand, without moulds, from synthetic clay pressed around metal armatures (plate 25). The basic forms are very simple with no applied decoration or pattern. Each piece was painted entirely in a single colour, usually a primary shade. Quite intentionally, the *Clay* works were made to look as if children had fashioned them from modelling clay; they were deliberately naïve, clumsy and ill-proportioned, like the outcome of an infant-school craft class, but at full scale. A graphic simplicity and obviousness characterizes the collection. Yet Baas is neither innocent nor a child, and his *Clay* furniture is an ironic take on the way an infant might set about designing objects with the tools and skills of the nursery. This witty faux-innocence disguises the fact that the collection conforms to the most sophisticated criteria of the art collector. Each piece is different from others of its type, meaning each is effectively a unique work, and every one is branded with the designer's name, fulfilling criteria

of exclusivity and novelty. The quirky forms and bright colours make *Clay* furniture instantly recognizable and differentiated in a crowded market, in which collectible design works all vie for the attention of the media, gallerists and collectors.

A similar aesthetic informed Baas' next project, *Sculpt* (plate 26). The title not only requests explicitly that we regard his furniture as fine art, but it also refers to the process of designing the collection, by means of small handmade models. Whereas conventional design development would refine the rawness of the first sketches and early models, Baas sought directly to replicate the individuality of the models in the full-sized finished work. Each piece – a wardrobe, a chest, various tables and chairs – expands the flaws of the miniature originals, so the final works appear to be

25. *Clay* armchair, 2006
Maarten Baas

giant models themselves. Forms and decoration have been treated reductively, yet the scale is massive and disconcerting. All structure is concealed and the appearance relies entirely on the effect of the mass and volume of each piece – that is, from its sculptural presence. Though naïve and lumpen, they are the result of painstaking hand labour. The table and wardrobe appear to be hewn from solid timber but are actually made of steel that has been veneered with walnut. Even the hinges are made by hand. These pieces are both monumental and comic, familiar yet strange, like the

26. *Sculpt* wardrobe, 2007
Maarten Baas

pseudo-1950s suburban furnishings of the popular *Flintstones* cartoon that they suggest. Their immediacy connects them to the moment of their inception by seemingly stripping away the layers of sophistication that are usually applied to a design as it is developed, or a piece of furniture as it is crafted. By playing with our conceptions of large and small, resolved and unfinished, and sophisticated and primitive, Baas challenges conventions of taste and quality through means that we expect from contemporary artists more than designers. The designer, therefore, models both practice and conceptual framework on paradigms drawn from the art world, which leads us to incorporate the language of art criticism into our reading of such works.

The French maker Vincent Dubourg appropriates nature in a very direct but sophisticated manner. His extraordinary furniture combines the classical proportions and rococo styling of traditional French provincial furniture with naturalistic renderings of twisted branches and saplings. Indeed, in works such as *Buisson* and *Napoléon à Trotinette* (plate 27, both 2007), made with fragments of a chair and a console respectively, the writhing organic forms suggest the origins of Rococo that lie in the works of nature itself. As Dubourg says:

> My objects are connected to history, be it distant or recent, because
> they re-assume existing forms. And it is the power of nature that,
> like an archaeologist researching an obsolete activity, suggests them
> anew to our eyes. For example, for me, this work with young tree
> branches begins not only with observation but also with dialogue.
> In these stems I see the potential of what they could become. It's as
> if nature had been watching us for a long time, and then suggested
> its own, new version of our repertoire. We give up, and it calls us
> back. For me, the material is also part of this idea of belonging to
> history. Thus, thanks to the bronze, the twig will forever be able to
> support a weight greater than its own.[18]

Other works by Dubourg are made using parts of found utilitarian metal cabinets and industrial ironmongery. Each object represents a pivotal point between nature and culture, but it is unclear which is dominant. Often, structural elements of the furniture have been replaced by twisting boughs, as if the finished, cultured artefact is regressing to the material that made it. Or are these representations of natural wood in the process of being marshalled and manipulated through craftsmanship into fine furniture?

Just as Boontje recasts timber and foliage in metal, and American artist and designer Michele Oka Doner casts tree roots in bronze to make candelabra, so Dubourg uses a similar technique to form his work. Both the furniture elements and the natural components of each piece are cast from bronze and other metals, like fine art. His furniture is not intended to be strictly functional. He says of his work, 'First and foremost, it's a desire to present sculptures, that is, *objets d'art* which neither proclaim their function nor necessarily appear useful at all. The functionality comes in at a later stage.'[19] These are chairs that are not made for sitting in, cupboards not

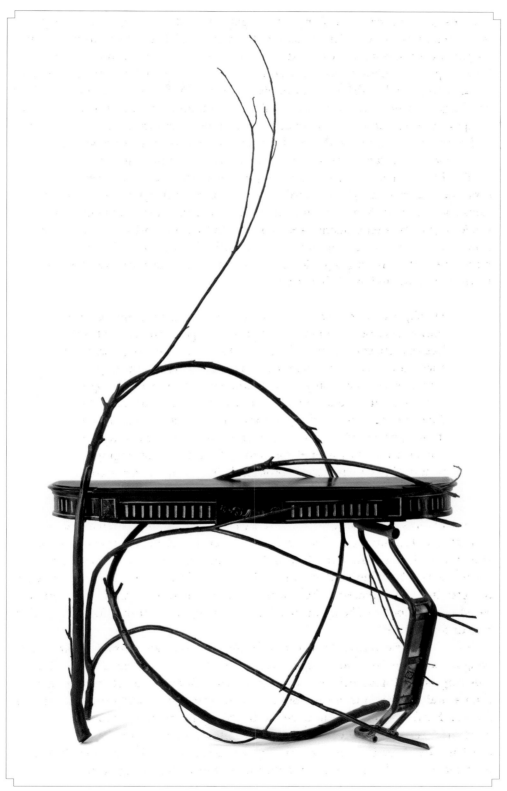

27. *Napoléon à Trotinette* console, 2007
Vincent Dubourg

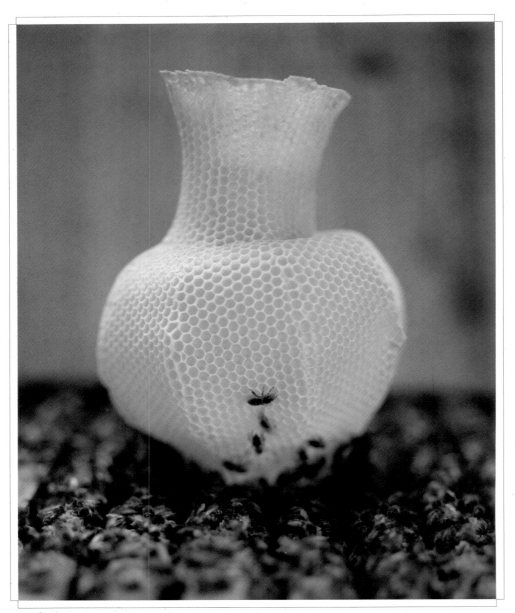

28. *The Honeycomb Vase 'Made by Bees'*, 2006
Tomáš Gabzdil Libertiny

meant for storage; rather, they are intended as objects of contemplation and decoration — as artworks. As such they form a contemporary continuum in the heritage of French decorative arts. His use of bronze, the archetypal material (along with marble) of sculpture and classical French furniture, reinforces this reading. Yet Dubourg studied industrial and furniture design in Nantes and Paris, and does not come from a fine art background, nor does he claim to be an artist. He generally shows his work in the context of design rather than art. But he produces his work himself, in small numbered editions of eight, like artwork. It is not possible to regard his furniture as design in the conventional understanding of the term because of the conceptual, sculptural purpose it espouses over and above its utility. The clash of deconstructed furniture archetypes with the rawness of nature reminds us of the interaction between culture and nature that Bey sought for his *Tree Trunk* bench. The difference between them is that Bey, perhaps in keeping with Dutch Calvinist conventions, takes a modest approach to his salvage of low-key natural and archetypal sources, more akin to Italian *arte povera*, whereas Dubourg, drawing on the somewhat grander perspective of his French artistic legacy, presents us with natural forms raised to cultural significance.

One of the more whimsical designs to have emerged from the Netherlands in recent years is the *The Honeycomb Vase 'Made by Bees'* (plate 28), designed by Slovakian-born designer Tomáš Gabzdil Libertiny in 2006. Like the works of Bey and Dubourg, the object explores the interaction of nature and culture. Libertiny made a frame for his vase, placed it in a hive and lured bees into it to build a vase-shaped honeycomb. He could have chosen to make any object type, but the choice of vase is important as 'the material comes from flowers as a by-product of bees and in the form of a vase ends up serving flowers on their last journey'.[20] Each vase is uniquely distorted and Libertiny had to estimate when each was completed. Usually it took about a week for a swarm of 40,000 bees to make a vase. The fragile and mis-shaped forms embody a particular Dutch aesthetic that values concept and content above finish or appearance. Most significantly, the eternal cyclical relationship of the flowers and bees is made explicit, and the vase's representation of its own narrative of production is a metaphor for the greater narrative of life cycles.

The notion of the Pastoral implies a disconnection from worldly affairs and an idealization of life lived at one with nature. Since classical times the simplicity and honour of the shepherd tending his flock has been a central motif in Western art. The importance to William Morris of Kelmscott Manor, his rural retreat, laid the foundation for a return to nature across all craft disciplines in the twentieth century. The veneration of the pastoral ideal has been both a singular blessing and the curse of modern craft. While it cannot be said that the designers and objects discussed here have been produced in the mainstream of the craft movement, nevertheless, the notion of the Pastoral — or nature revealed and simplicity celebrated — connects all these works to each other, whether the designers realise it or not.[21] A recent example of pastoralism is a collection called *The Farm* (plate 29), designed by Studio Job (Job Smeets and Nynke Tynagel) in 2008. *The Farm* celebrates the simple tools and furniture of a peasant farmer, and is apparently an ode to the designers'

own country roots. They created 23 utilitarian and archetypal objects, such as forks and pails, boots and bowls, but exaggerated and elevated them by casting each one in gilt bronze, a favoured material of the designers. The bronzes were complemented by simple furniture objects that served as plinths for these sculptures. The collection, commissioned for the Zuiderzee Museum, Enkhuizen, in the Netherlands, both idealized and caricatured the Pastoral by fetishizing traditional farm implements.[22] The poverty of rural life is entirely overlooked and even the Calvinistic simplicity of the implements, and by association the way of life they represent, is obliterated by the sheen of the gilt bronze.

The designer Ineke Hans similarly seems to pastiche Low Country rural pastoralism in her work, and sometimes even in her personal style, with references to Dutch national dress. Folk-art motifs, such as hearts and flowers, pervade her objects,

29. *The Farm*, 2008
Studio Job

which, perhaps contrarily, are made of contemporary materials including recycled plastic. The *Laser* chair (plate 30), made in batches since 2002, evokes the naïvety of paper-cuts. She describes it as a 'folklore chisel job', when in fact the pierced pattern is the result of sophisticated computer-controlled laser cutting. She continues, 'I think quite a lot of my designs have a strange kind of relation to reality. It is not always what you expect in the first instance.' The *Laser* chair is typical of many of her furniture designs, which seem to have escaped from an Arthur Rackham fairy-tale illustration and are obstinately anti-Modernist. However, Hans makes another connection. 'The pattern on the seat somehow reminds me of the first Thonet chairs,

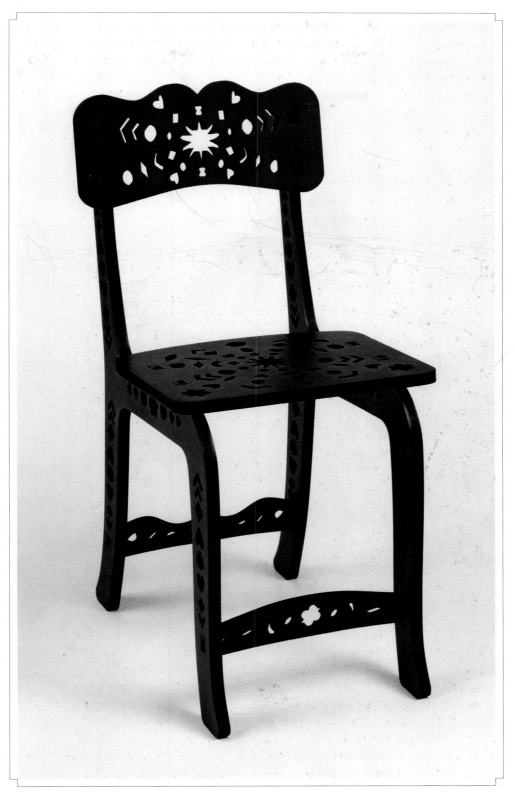

30. *Laser* chair, 2002
Ineke Hans

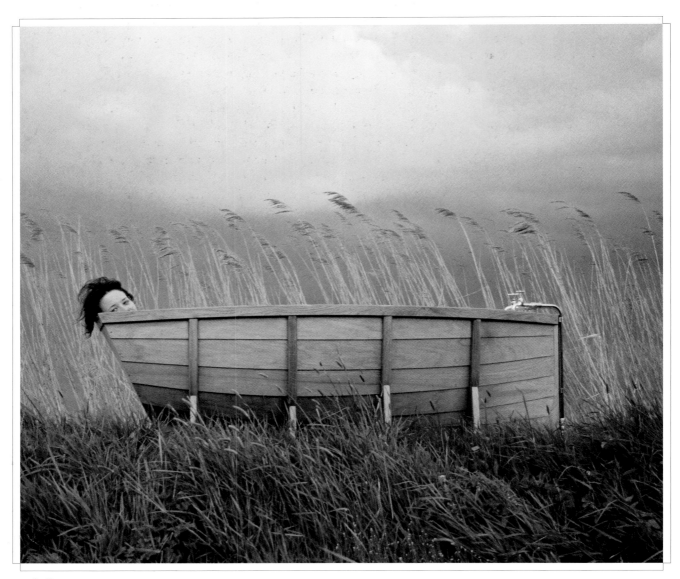

31. *Bathboat*, 2005
Wieki Somers

with their flower-embossed seats.'[23] The association with Thonet, the first truly mass manufacturer of furniture, may seem to undercut the pastoralism of her designs, but interestingly forms a link between earlier industrial processes and those used to make the *Laser* chair.

'The underlying stories and meanings of the final products are important, but they never dominate,' says Wieki Somers, explaining the relationship between concept and function, and artistry and design, in her work. 'More important to me is the way a user can somehow feel the combination of the content and the inherent value of the materials, which come to the fore in the process of making. I see myself as a mediator who succeeds in bringing out the best of all possibilities that hide in a material. And those possibilities include not only stories, and historical and cultural meanings, but also sensuality, the value of tactility.' A good example is her *Bathboat* (plate 31), designed in 2005 and produced in an edition of 30 by Galerie Kreo in Paris. It is like a small boat turned inside out, designed to keep water in rather than keep it out. 'If you take a bath in the Bathboat, you have the feeling of floating on the water. Bathboat shows how I capture a personal memory in an everyday object. Floating *on* the water and bathing *in* the water evoke many similar feelings and suggest similar elements that have been combined here in one installation.'[24] The bath is mounted on a frame reminiscent of the blocks that support boats in dry docks. Like Bey, Somers takes familiar forms and gives us an opportunity to let our imaginations run riot.

All these designers, in different ways, seek to reconnect us to a state of childlike wonder but they do not intend us to regress into immaturity. Instead, they want us to rediscover the universal truths that exist in fairy tales, rites of passage and the Pastoral, and which explain our place in the world. We cannot turn back time, or return to the Garden of Eden. Neither can we unlearn the lessons of adulthood. Instead, these designers use degrees of irony to parody and subvert our assumptions and values, so we can suspend our disbelief and approach the world anew.

THE ENCHANTED CASTLE

'Well, don't let's spoil the show with any silly old not believing,' said Gerald with decision. 'I'm going to believe in magic as hard as I can. This is an enchanted garden, and that's an enchanted castle, and I'm jolly well going to explore.'[1]

E. Nesbit

The idealized forest glade supplied an analogy for the pastoral, fairy-tale quality uniting the objects discussed in our first chapter, but now the story continues. We leave the forest, as it were, and enter the next staple location of fairy stories, the enchanted castle. From the pastoral and innocent, we pass to the opulent and knowing.

The American author Edgar Allen Poe's *Philosophy of Furniture*, written in 1840, remains prescient, even if the particulars have changed. For Poe, taste in furniture reflected national character. 'The Scotch are *poor* decorists. The Dutch have, perhaps, an indeterminate idea that a curtain is not a cabbage. In Spain they are *all* curtains — a nation of hangmen. The Russians do not furnish. The Hottentots and Kickapoos are very well in their way. The Yankees alone are preposterous.' As an American himself, Poe focused on American taste, which, he determined, was dedicated to ostentatious displays of wealth and confused magnificence with beauty. In the absence of genuine nobility by birth, nineteenth-century American society created nobility through wealth, and this in turn directly affected aesthetics. 'In short,' Poe concluded, 'the cost of an article of furniture has at length come to be, with us, nearly the sole test of its merit in a decorative point of view — and this test, once established, has led the way to many analogous errors, readily traceable to the one primitive folly.'[2]

Cost, therefore, translated for Poe as aesthetic value as well as pecuniary worth, and a century and a half later, what has changed? In this chapter, we look at contemporary designers who celebrate, plunder, satirize and transform our conventional taste for ostentation. They mine a rich seam of decorative forms that were first developed to express status, but here are generally treated ironically or with self-reference. Most commonly they use clashes of scale, or seemingly inappropriate materials and means, to achieve the disjuncture they seek. By making ordinary and familiar objects seem extraordinary and unfamiliar, these designers invite us to reconsider our passive acceptance of what is normal or acceptable. Noticeably, they often revive or evoke the bourgeois taste and manners of a pre-Modernist, pre-twentieth-century era, before the Viennese architect Adolf Loos associated ornament with crime.[3]

The shift from innocence to worldliness, from pastoral surroundings to the urban and urbane interior of the early Modern period, reflects the way narratives have changed. The invention of the printing press by Johann Gutenberg in about

1440 ultimately gave rise to a literate Western society, largely and increasingly urbanized, for which published stories had developed into novels by the early eighteenth century. Whereas earlier narratives were the metaphorical stories of Everyman, to be shared communally by a non-reading populace, the new novels individuated both characters and places, seeming to represent actual life and reality. Daniel Defoe's *Moll Flanders* (1722), for example, depicted the extreme yet believable life of a low-born woman seeking to retain her virtue and gain a husband. Set in London, Bath and the American colonies, the novel painted a picture of seventeenth-century life familiar to early eighteenth-century readers. Moreover, while the character of Moll is presented as a credible, rounded individual, the whole novel can be read as a satire of capitalist greed, since every human relationship in it is reduced to a mercantile transaction: Moll is not only little more than a prostitute; she also acts as a literary metaphor for

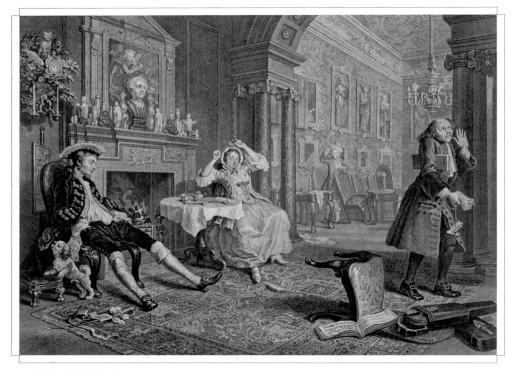

32. *Marriage à la Mode*, plate ii, 1745
Bernard Baron (1696–1762) after William Hogarth

avarice. Defoe, therefore, attempted to depict the narrative of daily life, but he also applied the same techniques to more fantastic stories, for example, that of *Robinson Crusoe* (1719), which was first published ostensibly as a true account by a real ship-wrecked sailor. Still more incredible was Jonathan Swift's character Lemuel Gulliver, who survives not only shipwreck but also dramatic variations in physical scale, riding on a flying island and living with talking animals, but whose adventures, nevertheless, are presented as real events. Of course, *Gulliver's Travels* (1726) was also a satirical novel first and foremost, but the way in which it stretched credulity chimes with

the irony employed by many contemporary designers. Both Jonathan Swift and designers such as Studio Job participate in this satirical tradition by parodying conventions of good taste and the values of their times.

These novels, and many others of the same period, relied heavily on scandal, intrigue and sensation. Samuel Richardson refined the novel with his tale of *Pamela, or Virtue Rewarded* (1740), told in epistolary form as a series of love letters from the protagonist. The added moral fibre found favour with the aspiring middle classes who read it. At the same time, the rise of engraved prints reflected and recorded the lives and morals (or lack of them) of the new urban classes, none more so than William Hogarth's *Marriage à la Mode*. Originally comprising six paintings (now in the National Gallery, London), painted between 1743 and 1745, the images were subsequently reproduced as engravings and widely disseminated (plate 32). The scenes are set in

33. *Smoke* mirror, 2007
Maarten Baas

typical Georgian classical interiors and depict the fashionable London marriage of the idle son of bankrupt Lord Squanderfield to the daughter of a wealthy, but miserly, city merchant. Loveless, the marriage (like those of Moll Flanders) was a mercantile transaction. Yet it leads to disaster as the husband is killed by the wife's lover. The final scene depicts her suicide after her lover's execution at Tyburn. The prints, therefore, are a parable on the folly of worldliness and wickedness.

Poe's description of tasteless American display, and Defoe's and Hogarth's depictions of sordid, materialistic eighteenth-century life, become the touchstones for our

34. *Robber Baron* cabinet, 2006
Studio Job

exploration of the designers discussed in this chapter. Maarten Baas' *Smoke* furniture is often made using reproductions of eighteenth-century types, and its shocking, burnt surfaces provoke us to think about the manners and values that the forms embody (plate 33). Objects such as longcase clocks, side tables and commodes are blasted with blow torches to blacken the exterior and partially destroy the decorative detail. Baas has even given similar treatment to larger objects, such as a grand piano. These are ghoulish and disturbing evocations of a middle-class eighteenth-century parlour as depicted by Hogarth or novelist Henry Fielding, where the outward decrepitude of the furniture symbolizes the inner decrepitude of the characters. This may be a theatrical way to interpret Baas' *Smoke* furniture, but even if fanciful, it recognizes the collection's visual impact. Its force derives from the sharp disjuncture between our expectations of polite, modest and well-mannered parlour pieces and their post-apocalyptic rendering: the chasm between comfort and discomfort. Baas produced his first *Smoke* furniture as a student at Design Academy Eindhoven in 2003, since when

35. Armoire, *c*.1700
Attributed to André-Charles Boulle (1642–1732)

it has become his leitmotif and signature style. Promoted by New York's style arbiter, design retailer and gallerist Murray Moss, these works have become the poster images of collectible 'design art'. Ironically, it is the poverty of the charred wood that lends value and charisma to such objects, in stark contrast to the opulent materials and techniques used by some other designers.

Poe dismissively quipped that 'the Russians do not furnish', but today the new Russians do furnish and the perceived lavish taste of the oligarchs is satirized by Studio Job. Much of their work contorts and re-forms historical motifs, often to satirical as well as decorative ends. Their designs are seldom principally functional, but usually arise from their observation of utilitarian and usable objects, such as

ceramic or metal tableware, as in *The Farm* collection (plate 29). They come from a design rather than a fine art background (they are both graduates of Design Academy Eindhoven), though they resist categorizing themselves as either designers or artists. 'Everyone knows that designers are not the smartest people in the world, otherwise they would become artists or something,' Job Smeets says, concluding that, 'It could be art, it could be nothing, it could be in-between. I hope that our work is a little bit artistic because otherwise it would be a little bit boring, it wouldn't show anything, it wouldn't be expressive.'[4]

Studio Job's series of five monumental objects, collectively titled the *Robber Baron* series, was conceived in 2006 and first presented at the Miami Art Fair in 2007. Subtitled 'Tales of power, corruption, art and industry, cast in bronze', it comprises a cabinet, a clock, a table, a lamp and a jewel safe, each made in an edition of only five, with three proofs. These objects are the product of artisanal workshop-based skills. Smeets and Tynagel sculpted each piece before it was cast by a specialist foundry, after which all the finishing processes, including patination and gilding, were undertaken by the Studio Job team.

The choice of gilded and cast bronze aligns the work with the finest historical furniture, as well as sculpture, while the excessiveness of the decoration intentionally recalls the extravagance of nineteenth-century American tycoons like the Rockefellers and new tycoons like the Russian oligarchs. Each object is a complex composition of contemporary imagery representing power and industry; clouds of pollution belch from factory chimneys, and in the relief decoration missiles and gas masks jostle for space with war planes. These motifs replace the classical imagery that usually embellishes ornamental bronze-mounted, or ormolu, furniture, and show how modern imagery can give furniture an allegorical purpose analogous to historical furniture. This is most evident with the largest piece in the collection, a cabinet (plate 34), modelled on three related armoires (now in the Wallace Collection, London; see plate 35). These pieces were made in the workshop of André-Charles Boulle, and date from around 1700. They share a common form, adapted and simplified by Studio Job. The most remarkable feature of Boulle's furniture, however, is the brass and tortoiseshell marquetry that encases it, but Studio Job have not attempted to replicate this decoration, or the finely chased mounts depicting allegories of the seasons. Instead, the density of the ornamentation is suggested by the relief panels of modern tools of industry and war. The door of one Boulle cabinet depicts Apollo ordering the Scythian to flay Marsyas, bound to a tree, and we are reminded that despite their beauty and classical harmony, this seventeenth-century furniture was also an expression of power, even of power secured and demonstrated with violence.[5]

Boulle's furniture relies on the striking contrast between the dark tortoiseshell and the brilliance of the brass. Studio Job's cabinet is entirely of polished bronze but still achieves the same contrast of light and dark, by different means. A vast ragged bomb crater, patinated black, is seemingly blasted through the (literal and metaphorical) dead centre of the cabinet. This shocking device cannot but focus our attention, but what is its significance? Are the designers celebrating wealth and status achieved

through industry or won through war, or are they appalled by it? The violent schism in the cabinet reveals the shallow nature of the decoration when used as an emblem of power; cast in bronze it becomes a permanent monument to destruction.

The other pieces in the collection are similarly rendered in cast, chased and patinated bronze. The table (plate 36) has a base in the form of a factory, an idealized 'palace of industry', the form of which derives from architectural icons such as Peter Behrens' AEG turbine factory and Sir Giles Gilbert Scott's Battersea power station. Its four towers are the table legs, and from them billows a cloud of (cast bronze) pollution. This represents power, too, and a different kind of violence – environmental despoliation. Like the cabinet, the table is at once sinister, opulent, tasteless and glamorous. The mantel clock, laden with visual imagery denoting power, taste and status, is supported by gilded oil barrels and stands on a base modelled on the arcades of the Uffizi Gallery in Florence. Its face resembles London's Big Ben and the

36. *Robber Baron* table, 2006
Studio Job

whole edifice is surmounted by a Neoclassical 'dream house', partially shrouded by cloud. The floor lamp piles architectural forms one upon another: the Empire State Building grows from the Parthenon and is topped by the dome of St Peter's, to which a Zeppelin is docked. The jewellery safe is surmounted by the sinister and surreal head of a Jack-in-a-Box.

The *Robber Baron* collection is, arguably, over-designed and over-specified, its means bearing no reasonable relation to its ends, and without modesty for its ambitions. But that is precisely the point. To see it as tasteless merely means that we are applying modernist quality judgements to non-modernist objects. Perhaps it is more useful to regard it as 'camp' in the sense that Susan Sontag defined the term in her influential essay 'Notes on Camp' of 1964. 'Camp asserts that good taste is not simply good taste;

that there exists, indeed, a good taste of bad taste.[6] The over-egged references to history, architecture and ornament are reminders of Mannerist art and high Baroque design, as well as the symbolic architecture and design of 1980s Postmodernism. Such references are legitimized by Postmodernist theory, which declared the equality of all cultural manifestations, whether high or low.

No Dutch designer uses tricks of scale to better effect than Marcel Wanders. His earliest works were among those taken into production by Droog Design, the famous platform for contemporary Dutch design in the mid-1990s, and of all his generation he has been the most successful in commercializing the Dutch conceptual design approach, most notably through products manufactured by Moooi, the company he co-owns and of which he is Art Director. In 2007, however, at the Milan Furniture Fair, Wanders presented a solo exhibition of limited edition works that included table

37. 'Bella Bettina', *Bell* series, 2007
Marcel Wanders

lamps expanded to architectural scale and a series of eight unique and equally vast decorative bells (plate 37). Each bell, moulded in polyester and painted by hand, is a metre and a half high and fitted with an internal lamp. Each is punningly given a girl's name, for example, 'Bella Belinda', 'Bella Bettina' and 'Bella Barbara'. Together with the lace-like or folk-art inspired patterns, the names and gigantic scale seem to comment on idealized beauty. Certainly they are principally fantastical and only secondarily of any utility, and Wanders describes them as 'girls in fancy dresses floating overhead, dressed up as silent bells absorbing the music in their ethereal dance'.[7] These are not among Wanders' best works, which are more questioning and genuinely innovative in their form and realization. But they are symptomatic

of an insatiable appetite for distinctive work by well-known designers. The scale of Wanders' works, and of his ambition, tells of renewed confidence among designers and the market alike.

Entering an interior furnished with Wanders' out-sized objects can be disorienting. Like Gulliver in Lilliput and Brobdignag, or Alice passing through the looking-glass, the discomfort of shifting scales makes us re-assess our surroundings. Kiki van Eijk used a similar disjuncture for her graduation project in 2000. She scaled-up a tiny fragment of carpet so that its pattern, and even the individual tufts of wool, became enormous (plate 38). The rose motif, drawn from chintz patterns associated with bourgeois taste, connects Van Eijk to other contemporary Dutch designers, such as Gijs Bakker, all of whom exploit the juxtaposition of familiarity and disjuncture. In a sense the figurehead of contemporary Dutch design, Bakker, jeweller and founder

38. *Kiki* carpet, 2001
Kiki van Eijk

of Droog Design, played similar games to Wanders and Van Eijk with his *Real* collection of jewellery. He took non-valuable costume jewellery as his starting point and combined it with replicas made of precious stones, using scale as well as materials to question what is real and what is fake (plate 39).

There are many designers who satirize and distort opulent taste, but with less savagery and arguably more subtlety than Studio Job or Marcel Wanders. Many of them are Dutch and many, like Van Eijk, graduated from Design Academy Eindhoven. They produce small editions of exquisite experimental furniture and design objects. Sebastian Brajkovic, who was an intern with Jurgen Bey, designed his *Lathe* chairs (plate 40) for his graduation project in 2006. They were shown at the Milan Furniture

Fair the following year and made in an edition of eight by the London gallery Carpenters Workshop. The chairs in the collection are each variants of a type of early- or mid-nineteenth-century side chair, with an upholstered seat and back, and a loosely Rococo or Classical profile. From this standard form, the designer created new chairs by stretching the traditional shape in different directions, rotating it around pivotal points at the front, back and side, as if it had been lathe-turned. The archetypal chair is still visible at the extremities, as is the decorative, naturalistic, embroidered uphol-stery; but in between it appears like a smeared image, or a speeding object caught on film. 'I love film,' Brajkovic says. 'My masters are Tartovsky, Bergman, Visconti. In a way they tell a story of a daydream world where things happen that won't happen in ordinary life. It is an extra-ordinary way of living. A way of stepping out of the com-monplace. Everybody wants that!'[8] Like all designers discussed here, Brajkovic uses conventional and recognizable shapes with which we can associate, but wrong foots us

39. *Real 3* ring, 2006
Gijs Bakker

by distorting them, to make us 'step out of the commonplace' and discover 'an extra-ordinary way of living'. This concept lies at the heart of Dutch contemporary design.

Jeroen Verhoeven is part of a small design group called Demakersvan, with his twin brother Joep and Judith de Graauw. They share a former warehouse studio in Rotterdam with Joris Laarman in the dockland area that also houses Richard Hutten, one of the original designers in Droog Design. All studied at Eindhoven. On a wharf nearby is the self-declared independent republic ruled by maverick artist and designer Joep van Lieshout. Jurgen Bey resides elsewhere in the city, as did Hella Jongerius until 2008. Rotterdam, therefore, has become home to a generation of the most influential young Dutch designers, many of whom share conceptual and formal similarities.

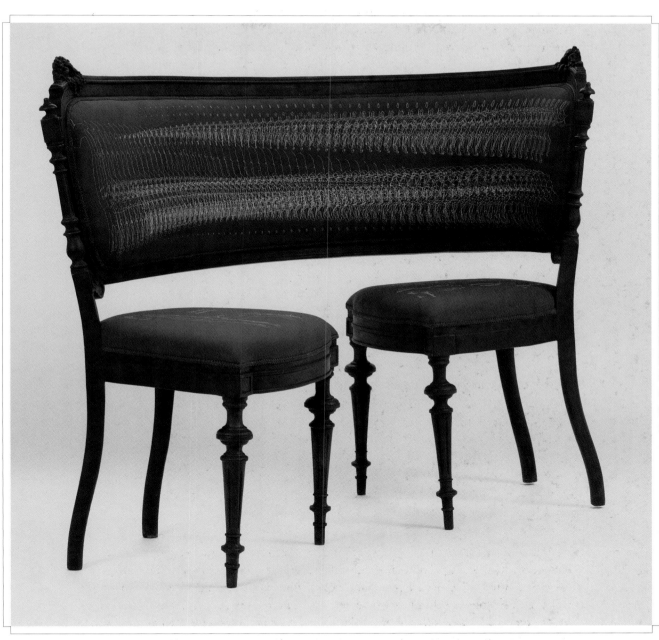

40. *Lathe* chairs, VIII, 2008
Sebastian Brajkovic

The most famous works by both Jeroen Verhoeven and his stable-mate Joris Laarman also satirize and contort historical taste and were designed while they were both still students. The stylized outlines of two types of opulent eighteenth-century furniture became merged into one new computer-generated form in Verhoeven's *Cinderella* table (plate 42). With this title, the designer wished to evoke the transformation of Cinderella by her fairy godmother as a metaphor for the way in which the 'craft' of modern computerized technology can transform mundane materials, revealing the design object within. The table was made in an edition of 20 and fabricated by a specialist boat builder, NEDCAM, a subsidiary of the Maritime Research Institute Netherlands (MARIN). Commodes, or chests with drawers, first appeared in France in the late seventeenth century and by the 1750s the form had spread to England and elsewhere. Parisian commodes of the mid-eighteenth century often had voluptuous bombé bodies with many compound curves to tax the skills of the cabinet

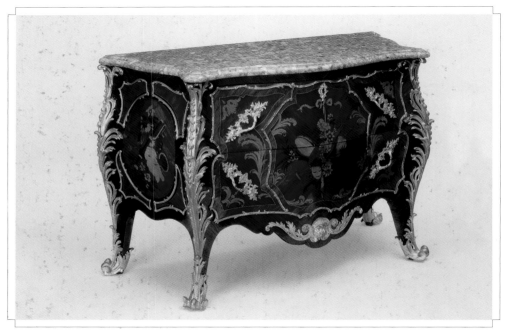

41. Commode, *c*.1765
Probably by Pierre Langlois (active c.1756–67)

makers (plate 41). These curves are visible in Verhoeven's two-dimensional outline of a simplified, archetypal commode form, from which the computer-generated volume of the *Cinderella* table emerges. Its plywood shell suggests the bombé carcase of an eighteenth-century commode but, in keeping with a contemporary aesthetic rooted in Modernism, the marquetry decoration and gilt-bronze mounts that would have embellished the historic archetype are omitted in favour of simply revealing the utilitarian material from which the table is made. The shape of the commode converges with the outline of a side table. Both object types are cultural status and taste indicators of their era (and, as antiques, remain highly sought-after emblems

today), but reworked they take on new and ambiguous meanings. Does this design celebrate or criticize the values of the past? With the work of Studio Job the battle lines are clearer, but Verhoeven is more even-handed. This interplay between notions of grandeur and excess, and ordinariness and humility, informs our understanding of the relationship between past and present in the design of the object. Like many of the designers discussed here, Verhoeven exploits the disjuncture between our embedded expectations of a historic precedent and the reality of its rendering by appearing to mismatch materials, techniques and forms, or by transforming the scale of the object.

Several years after the inception of the design, and after he had made all 20 plywood tables in the edition, Verhoeven translated the *Cinderella* table into marble in 2008 (plate 43). The first work in this edition of six was alledgedly purchased by film actor Brad Pitt, confirming the glamour of 'design art'. The same technology was applied

42. *Cinderella* table, 2005
Jeroen Verhoeven

as for the plywood version and the form was built up from sections of CNC-cut stone (CNC is the acronym for 'computer numerically controlled'). Marble, the material of classical sculpture, has been used by other designers, notably Marc Newson for his *Voronoi* shelf and *Extruded* chair (plate 9), shown at the Gagosian Gallery in New York in January 2007, and by British-based Established & Sons for special versions of its limited edition furniture. In both, the choice of marble clearly signalled the aspiration for these design works to be considered as art. The thin marble wall of the *Cinderella* table, only about 18mm thick, allows light to pass through, and the whole object appears more than ever like a translucent shell. But the essential character of the original

43. *Cinderella* table, 2008
Jeroen Verhoeven

plywood version, which contrasted high and low signs and signifiers in a complex tug of references between history and modernity, is compromised. While it demonstrates a virtuoso handling of material, the table loses an element of humility.

Gareth Neal, one of the few non-Dutch designers to be discussed in this chapter, is primarily a furniture maker, with a training and background embedded in the British craft tradition. His *Anne* console table (plate 44) and *George III* chest of drawers, both named after eighteenth-century British monarchs, combine the profiles of classic Georgian furniture with minimalist, block-like volumes. Slices are cut at variable depths into the surface, giving the impression of one form contained within another, and the striations of the routered wood have a similar effect to that of the layers of plywood veneer used in the *Cinderella* table. Both Neal and Verhoeven contrast organic curvilinear historical styles with straight-edged, mechanically produced materials and techniques, creating a friction between the past and the present. Neal's

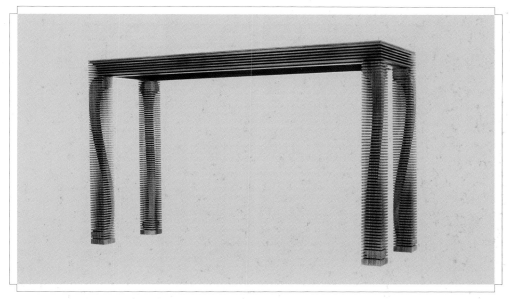

44. *Anne* console table, 2007
Gareth Neal

furniture is subtler than Verhoeven's, and less ambitious in its technique, but both subdue the opulence of their historical references with neutral and natural materials. The *Anne* table was Neal's first piece in this series and he observed that the shape of the cabriole legs could only be seen when the table was viewed at a very low angle, allowing sight lines into the sliced cuts. This compromised the impact of the piece, so he cut back some areas of the outer volume of the later *George III* chest of drawers to make the outline of the bombé commode inside more visible. What appears as casual or accidental surface damage adds another dimension of random intervention to a design that had hitherto solely relied on the disciplined interplay of rectilinear and curvilinear aspects. In parallel with Verhoeven, Neal subsequently translated his wooden table into LG Hi Macs, a type of artificial stone.

45. *Clone* chair, 2005
Julian Mayor

Where Verhoeven chose to smooth off the surface of his table, creating a homogenous volume that reveals its origins only through the stripes of the plywood, Julian Mayor deliberately assembled his *Clone* chair from blocked layers (plate 45). This enhances the constructed nature of the design, giving it the character of a rudimentary computerized wire-frame drawing. By 'digitizing' his eighteenth-century form, as it were, Mayor added a further layer of complexity to the relationship between historical and contemporary furniture styles and construction. Additional visual interest arises from the plywood layers, which, instead of following the symmetry of the chair, are offset, so that the left side of the chair is constructed differently from the right. Together, these furniture designs by Verhoeven, Neal and Mayor, produced on a domestic scale, present a contemporary impression of the eighteenth-century fashionable interiors found in the prints of Hogarth.

The effect of digital pixelation achieved through low-tech means in Mayor's chair also characterizes a collection of furniture and objects by Jurgen Bey called

46. Armchair, c.1750—60
Matthias Locke (d. 1765)

47. *Pixelated* chair, 2008
Jurgen Bey

Witness Flat, presented at the Galerie Pierre Bergé & Associés in Brussels in 2008.[9] The exhibition featured a 'show apartment' with furnished rooms, in which Rococo-style furniture (see plate 46) was constructed from common materials: untreated softwood and un-dyed felt. While the tables, desk and bed appropriated the forms of industrial pallets, some of the chairs, a wardrobe and a sideboard were built up from small blocks of timber, about 44 × 18mm, stapled together to create the impression of enlarged low resolution images. The upholstery for the chair seats was made up of soft felt blocks, confusingly stitched with faux-wood grain to add an additional layer of disjuncture. As before, the impact of the 'pixelated' furniture depends on our recognition of the historical shapes, with all their cultural baggage, starkly contrasted by their seemingly inappropriate

rendering in poor materials. The rudimentary construction technique flies in the face of accepted standards of craftsmanship, but is in contrast to the hand-sewn felt elements, which simulate not only wood grain but also tiny screw heads. By suggesting that the objects have been over-enlarged, the pixelation technique plays with our perception of size and detail, recalling the designs of Marcel Wanders and Kiki van Eijk. It is left to our imagination to model each individual wood or felt pixel into a conventional ornamental device, such as a turned baluster leg or carved crest.

Many of the objects in this chapter suggest Sontag's 'Notes on Camp'. She argued that camp taste equated to a love of the unnatural, an appreciation of artifice and of exaggeration, and a preference for stylization rather than natural beauty. The long eighteenth century, in all its stylistic manifestations, is a reference point for these designers, just as nature and pastoralism is for others. Comparably, Sontag reasoned that, 'In the eighteenth century, people of taste

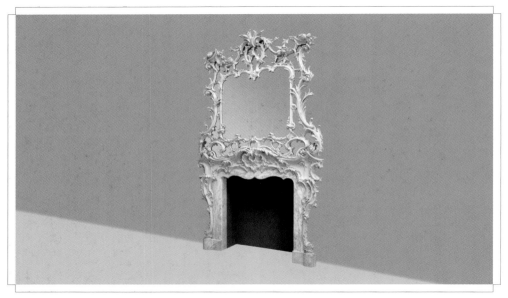

48. Chimneypiece, c.1750
Maker unknown. From Winchester House, London

either patronized nature (Strawberry Hill) or attempted to remake it into something artificial (Versailles). They also indefatigably patronized the past. Today's Camp taste effaces nature, or else contradicts it outright. And the relation of Camp taste to the past is extremely sentimental.'[10]

Joris Laarman has a taste for the ornate decoration of the past, a predilection inherited from the first wave of Dutch conceptual designers. As Sontag expressed it, 'The hallmark of Camp is the spirit of extravagance', and Laarman is very aware of the ironic, camp potential of his objects. He employed generically ornamental, and certainly anti-Modern, rococo styling (see plate 48) for his cast concrete *Heatwave* radiator (plate 49). Radiators need large surface areas to work effectively,

which was one criterion governing his choice of rococo scrolls. But the use of an ornamental motif such as this is loaded with critical and historical resonance: 'In a time of arbitrariness and opportunism I am searching for ornamental but somehow necessary form,' he said in an early interview. 'Modernistic functionality and post-modernistic effusiveness do not have to exclude each other. I wanted to demonstrate that functionalists are also sinners of styling, and that soberness is not always more functional than highly decorative form.' He added, 'The radiator was to make my point that modernism was wrong and that post-modernism is also wrong and that everybody is wrong.'[1]

Aided by such provocative statements, the *Heatwave* earned Laarman much media attention and the few prototypes that were produced were eagerly acquired by museums such as the Boijmans van Beuningen Museum in Rotterdam and for collections such as that of the FRAC (Fonds Regional d'Art Contemporain) in Orleans, France. Unusually for the objects featured here, the design gained a second life as a

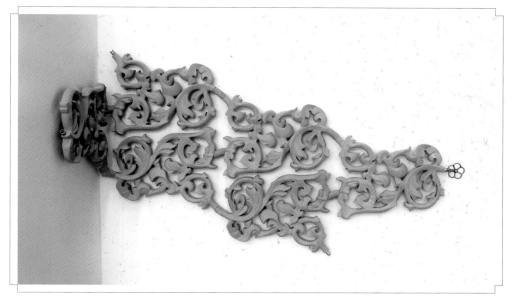

49. *Heatwave* radiator, 2003
Joris Laarman

mass-produced object, made of lightweight concrete and aluminium reinforced with glass fibre by Jaga in Belgium. It shows that even extreme statements of style and taste can be translated into workable products. 'I want to have a certain amount of *reality* in my design so things have a *meaning*. *Styling* is only one layer. But I think reasoning can also have poetry in it. A certain amount of poetry and a certain amount of reasoning, and also a bit of kicking the arse of the establishment – that's what I want to achieve.' Elsewhere Laarman is more philosophical about his design approach.

> I see myself as a filter of my time. My objects are an expression of this. Some people write books, others make music and I make objects. My

objects are trying to explain, in times full of arbitrariness, that it can be beautiful when shapes are there, not just because I like them, or a marketing manager likes them, but because it just makes sense. A kind of super-logic that makes you think about why things actually look like they do. I like to create an alternative interpretation of objects.[12]

Boym Partners (Constantin and Laurene Leon Boym) take a provocative stance like Laarman, and consider their approach to be the closest thing the United States has to Dutch-style conceptualism. *Ultimate Art Furniture* is a collection of unique objects that aims to provoke debate about the blurring of art and design (plate 50). It was a response to the brouhaha surrounding the media's discovery of 'design art', and the notion that designed objects no longer need to be hidebound by functionality but can be (metaphorically speaking) 'blank canvases' for the expression of ideas by a designer. Boym Partners took artworks as the material for their designed objects, literally making furniture from 1980s reproduction canvases of Old Masters, such as Veronese. Taking the chair as his example, Constantin Boym explains:

Art becomes a new material to make the furniture with, which opens many narrative possibilities … the chair expresses different sentiments and feelings by virtue of the paintings it is made of … When design becomes art, there is a possibility to re-imagine the object in a very different and radical way. Like in painting, cinema, or literature, life itself becomes the theme of a designer's work. The chair could be about love, or war, or death, or disaster – and not necessarily about the comfort of sitting! The subjects of design expand to such degree that we can only imagine the possibilities that lie ahead.[13]

The objects in the *Ultimate Art Furniture* collection have a common spirit derived from the friction between the simplified forms of the furniture and the ornate Baroque images on the upholstery, in much the same way as Verhoeven and Neal contrast the forms of the past with those of the present. It is as if the paintings have slid from the walls and folded themselves into furniture, physically and metaphorically demoting the traditional status of fine art to that expected of decorative or applied art. But unlike the *Proust* chair, discussed in the Introduction, which also elides painting and furniture, the chairs and tables are not 'useful' in any real sense, so the convention of art as a symbolic and contemplative commodity is restored. The unexpected jolt of discovering a familiar object type used 'incorrectly' also owes much to Surrealism.

The intrinsically literary character of contemporary design is particularly evident in Richard Hutten's table, made entirely of books (plate 51). Like the Boym Partners' collection, this piece is literally constructed from another art form. The table was taken from a collection called *Layers*, presented by Hutten at Galleria Facsimile in Milan during the Furniture Fair in April 2008, which comprised furniture created from different strata. He commented:

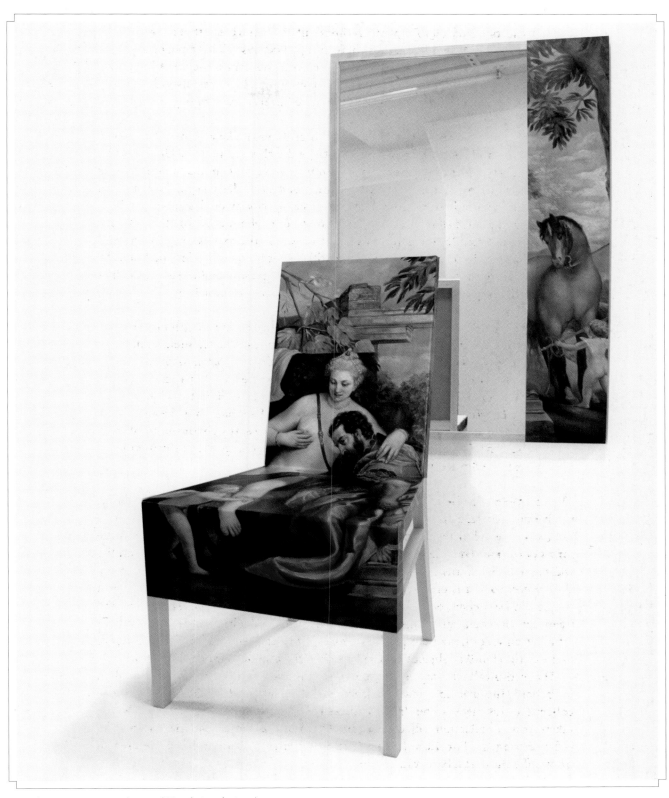

50. Ultimate Art Furniture (*Venus and Mars* chair and mirror), 2006
Boym Partners

A book is all about layers, layers of meaning. This collection is about objects and what we can read in them. Design is not only about beautiful forms, but also about the stories an object can tell. I positioned myself as an artist in this collection, and therefore also as an anthropologist and sociologist, trying to stir up the discussion and discourse on objects. But the fun of making these objects was equally important. The conceptual and manual coincide in this collection, and overlap.[14]

The books are saturated in resin that hardens and binds them together. While the legs are simply columns of books, the top contains a substrate to support it. No matter; the conceit of making the books appear to levitate is worth the illusion required to achieve it. For the first table in the edition of eight he included hardback covers only, without illustrations, so the books became simplified coloured bricks within the

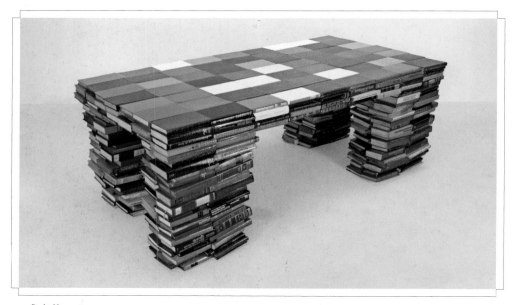

51. *Booktable*, 2008
Richard Hutten

whole. For further tables, he has considered incorporating a textual layer by juxtaposing titles (the Bible beside the Qur'an, for example), but these remain unmade.[15]

All these examples show designers re-casting the styles and forms of the past in ways reflective of today. What were sometimes functional objects are now re-interpreted decoratively, and what were tokens of status are subverted ironically. Connecting them all is a robust but often irreverent respect for history and what we can learn from it. Two recent projects, perhaps more than any others, show how historical antecedents, in the hands of talented designers and highly skilled artisans, can marry the past and the present. Moreover, both projects resulted in exclusive, distinctive and luxurious objects well suited for the 'design art' market.

52. *Diamonds are a Girl's Best Friend 1* lantern, 2008
Matali Crasset

The first collection of objects manufactured by Meta included, alongside Boontje's *Fig Leaf* wardrobe, a lantern designed by Matali Crasset called *Diamonds are a Girl's Best Friend 1* (plate 52).[16] The title is that of the song from the 1949 Broadway musical *Gentlemen Prefer Blondes*, based on Anita Loos' novel of 1925 and famously performed by Marilyn Monroe in the 1953 film adaptation. The lantern is shaped like an enormous cut-diamond pendant, containing a smaller diamond within it, and is a reinvention of a classic glazed hall lantern. Exaggeration of scale, ironic opulence and allusions to musicals and Marilyn Monroe all suggest we are firmly in Sontag's camp territory, but this object also tells another tale about materials and craftsmanship. The metal armature of the lantern is made of paktong, an alloy of copper, zinc and nickel developed as early as the twelfth century in China and prized both for its sonorous qualities (it was used to make bells) and because it looked like a cross between gold and silver and would not tarnish. Small quantities of paktong reached Europe during the eighteenth century, despite an export ban, and its potential as a durable substitute for silver was explored. But by the 1820s nickel silver (a misleadingly named alloy containing no silver but intended to emulate it) had been developed and the ability to make paktong was lost. In order to make this lantern, Meta sent a paktong candlestick of 1720 to Oxford University's archaeological science unit to be analyzed, and commissioned Belmont Metals, a family-run metallurgy business founded in Brooklyn in 1896, to make the 16 ingots needed for the frame. In keeping with this level of perfectionism, Glashüette Lamberts in Waldsassen, Germany, one of the last producers of traditional, mouth-blown sheet glass, made the 24 panes as modern float glass would not suffice. This attention to detail, and the collaboration of contemporary designers with highly skilled artisans, is typical of the Meta philosophy, which has one more distinctive feature. Despite the labour-intensive production and the ensuing high price tag, Meta does not envisage these as limited edition 'design artworks' for the auction houses and collectors' market, but simply as top quality products that have inbuilt exclusivity imposed by price and availability. Giles Hutchinson-Smith, the London-based managing director of Mallett's, the parent company of Meta, explained that 'production techniques and materials dictate how many pieces we produce annually — as few as three for some designs and, for others, perhaps six or eight. The paramount focus is on timelessness and longevity.'[17]

The Meta collection is an example of corporate patronage of high-end design, as is the promotion of avant-garde designers by the oldest firm active in the Netherlands, Royal Tichelaar Makkum. This ceramic manufacturer is situated in the fishing village of Makkum, on the east coast of the Ijselmeer in Friesland, northern Holland. As early as 1572 maps showed a brickyard on the site; by 1670, it was primarily a domestic pottery. The Makkum manufacturer has been in the continuous control of one family since 1640, the present Managing Director, Jan Tichelaar, representing the thirteenth generation at the helm. During its venerable history, the company has accrued a wealth of expertise in the production of ceramics. In 2004 the Rijksmuseum in Amsterdam acquired a pair of tulip vases, made in Delft in about 1695, and turned to Royal Tichelaar Makkum to restore them. Another pair, from the collection of the first Duke of Portland, is now in the Victoria and Albert Museum.[18] The company

researched and refined the exact materials and techniques used in the seventeenth century in order to restore the museum pieces, and also gained the Rijksmuseum's permission to replicate one (plate 53). In order to capitalize on the expertise gained from this exercise, Tichelaar invited four contemporary designers to rework the original form of the tulip vase, bringing it up to date.

Tulips are emblematic of Holland, of course, and together with the elaborate vases that were developed to display them, they hold a special place in Dutch visual culture. But tulips have significance elsewhere, too. They originated as wild flowers in central Asia and were cultivated by the Turks as early as the eleventh century, before being introduced into Holland in 1593 by Carolus Clusius, who planted the first tulip in the Botanical Garden in Leiden, into Britain in 1578, and into France in 1598. Today's

53. Tulip vase, 2008
Royal Tichelaar Makkum, after an original in the Rijksmuseum, Amsterdam

tulips are the result of commercial production systems and intensive hybridization, and it is easy to overlook their rarity in previous centuries. In seventeenth-century Holland an entire culture of gardening and displaying flowers grew up, led by William of Orange who, with his English wife Mary, ruled England and Scotland from 1689. The spouted vases that were developed specially for the display of tulips are known from as early as 1658 and their shapes were inspired by porcelain imported from China by the Dutch East India Company, which was established in 1602. Manufacturers in Delft specialized in earthenware emulations of Chinese porcelain, giving rise to the familiar blue-and-white ceramics still associated with the city today. The pyramidal

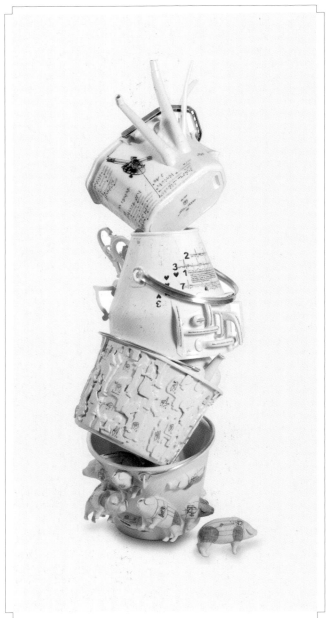

54. Tulip vase, 2008
Hella Jongerius

55. Tulip vase, 2008
Jurgen Bey

56. Tulip vase, 2008
Alexander van Slobbe

57. Tulip vase, 2008
Studio Job

forms, intentionally resembling pagodas, were configured to set off the flowers to best advantage and were constructed in separate layers, with water reservoirs in each section. At the peak of their popularity in about the 1690s, these pyramids could reach over 150 centimetres high. The French émigré Daniel Marot, the most fashionable designer of his age, was responsible for designing some of the finest vases, including examples that left Delft for England at the request of William and Mary, thus exporting the tulip craze to a new market. Cosimo de' Medici is also known to have patronized the factories in Delft.[19] Such regal and aristocratic patrons may have declared a love of beauty, but the unnatural display of hybrid flowers can also be equated to a display of status by those in command. After all, only the rich and powerful could afford the luxury of artifice. Tulip pyramids, therefore, signify the pinnacle of royal taste, design patronage and technical virtuosity. Their forms and purposes have crossed continents as a result of the trade in culture and artefacts between east and west.

The *Pyramids of Makkum* collection comprises four extraordinary vases designed by Hella Jongerius, Jurgén Bey, Alexander van Slobbe and Studio Job, with a fifth vase replicating the seventeenth-century original. Made in an edition of seven, the first set was pre-ordered by the Zuiderzee Museum, Enkhuizen. These are not the first contemporary designers to have experimented with the tulip vase form; both Wieki Somers and Ineke Hans have designed their own interpretations. What is exceptional about the *Pyramids of Makkum* collection is the scale of the objects and their direct reference to a particular historic object. The only restriction placed on the designers by the manufacturer was that the new vases should be approximate in volume to the original.

The form and decoration of the seventeenth-century original is clearly visible at the base of Jongerius's vase (plate 54). However, she has radically re-orientated it by adding an enormous handle to one side, rather like a jug, using this to hang it from the wall. Jongerius designed her vase in sections, like traditional tulip pyramids, and to prevent them separating in this new position, she has inserted lengths of industrial strapping, held tight with metal clasps. The incongruity of these straps and the addition of the handle are characteristic of the designer's ceramics, which often juxtapose modern and ancient stylistic, even material, elements. Rising through the tulip vase, the decoration gradually dematerializes, becoming reduced to stylized blue-and-white stripes and finally, at the finial in the shape of a bust, losing all colour.

In contrast Jurgen Bey discarded the pyramidal structure of the original vase and instead designed by far the most esoteric of the four new designs, a stack of stylized buckets (plate 55). Each represents a different function: a feeding bucket, a building bucket, a milk churn and a cleaning bucket, all embellished with symbolic decoration. 'It looks like a chaotic collection of individual stories, but is this apparent disorder accidental or some form of unfathomable balance?' Bey asks. Answering his own question, he continues, 'Who knows; probably a subtle orchestration has been responsible for stapling [*sic*] the dishes, the invisible hand of life itself.'[20] Bey summarized his intention as 'the world explained in a collection of curiosities' and designed a balsa wood carrying-crate for the vase's components, complete with miniature vases for feet, each bearing the identity

of one of his studio members. Taken as a whole, Bey's tulip pyramid is a contemporary interpretation of both cosmology and the 'Kunstkammer', with subtle waves of reference backwards and forwards through the histories of design and art, making and collecting, and communicating through objects.

Royal Tichelaar Makkum had previously collaborated with the fashion designer Alexander van Slobbe in 2006 to make outsize ceramic jewellery (an interesting diversification for the company). Like Bey, van Slobbe jettisoned the conventional shape of the vase altogether. Instead, recalling the original tiers of the pyramid, he designed a series of stacked boxes in the shape of furniture, dishes and perfume bottles in which to store fashion and beauty accessories (plate 56). 'My vase is not primarily intended to carry that seventeenth-century symbol of affluence, a tulip,' the designer said, 'rather it is the carrier of an idea; an outrageously luxurious wrapping of an idea called fashion.'[21]

Studio Job produced a design that relates both to their *Biscuit* collection of porcelain, previously manufactured by Royal Tichelaar Makkum, which smothers traditional forms with their trademark patterns, and the *Robber Baron* collection of furniture. Coincidentally, the original sources of inspiration — the tulip vase and the Boulle armoire — both date from close to 1700 and represent royal taste. In keeping with the tiered hierarchical forms of traditional tulip pyramids, Studio Job's vase piles objects and motifs upon one another to form a column (plate 57). Like the lamp in the *Robber Baron* series, the body of the vase represents a skyscraper emerging from a gilded cloud, in this instance emanating not from an industrial chimney but from an oversized ornamental tobacco pipe. The skyscraper is surmounted by a coffee pot, belching gilded steam, and above it all a decorated kettle cantilevers from a chute of gilded boiling water. The whole effect is surreal and bombastic, relying on exaggerated scale, intense decoration and the improbably luxurious rendering of mundane household implements, which are certainly not the props of royalty.

Artifice, sentiment, exaggeration and irony abound in these designs, which call upon a historic repertoire of motifs and forms, imaginatively conjuring and parodying an idealized, opulent past. In fairy stories, the enchanted castle is likewise furnished with opulence as befits a stage for ceremonies such as weddings or coronations. For Hogarth, and the writers of eighteenth-century novels, the styles of interior design of that period indicated status and self-satisfaction. Why are contemporary designers so interested in historical styles, which they do not reproduce slavishly so much as reinvent? Does this make them reactionary or avant-garde, backward-looking or guides to the future? The past clearly holds fascination for them all, as do the trappings of status that they parody. Perhaps they mourn the past, which, as Sontag concludes 'is why so many of the objects prized by Camp taste are old-fashioned, out-of-date, démodé.'[22] By deflating the status symbols of the past, they are acknowledging the mutability of all material goods, and ultimately the inability of objects adequately to represent our identities and self-worth. This is in itself an ironic stance for a group of designers engaged in producing expensive goods for an elite market.

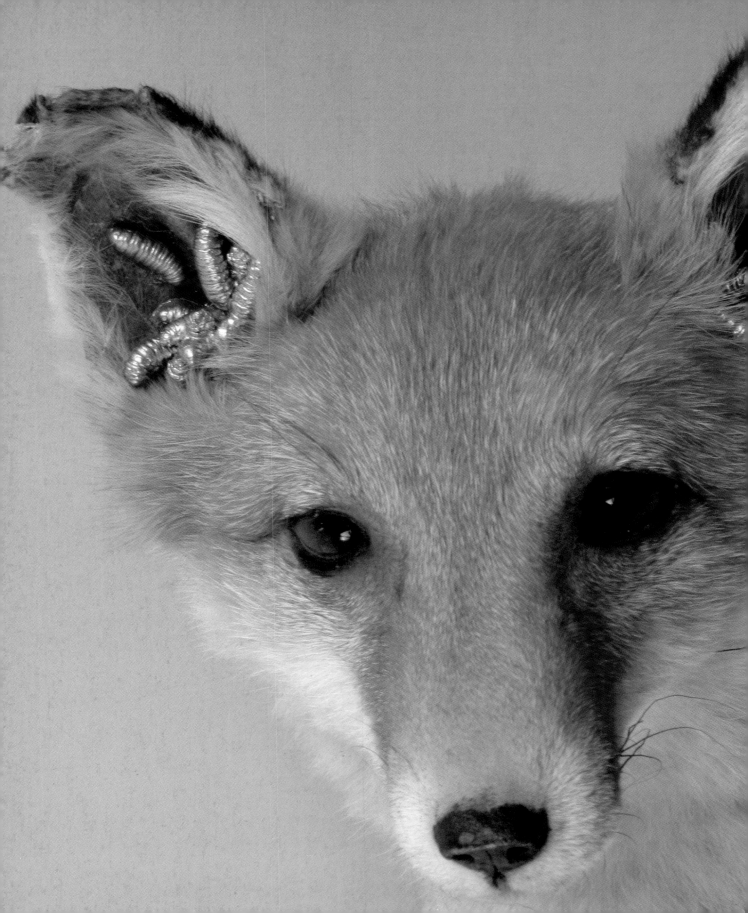

HEAVEN AND HELL

Death is the sanction of everything that the storyteller can tell. He has borrowed his authority from death.[1]

Walter Benjamin

From the pastoral innocence of the forest glade, and the opulence of the enchanted castle, we now turn to a third thread of narrative in contemporary design: our anxieties and fears about our own mortality. Life is mutable and death is unavoidable, or, as the philosopher Schopenhauer put it, 'Dying is certainly to be regarded as the real aim of life; at the moment of dying, everything is decided which through the whole course of life was only prepared and introduced.'[2] The inevitability of death legitimized the story-teller for Walter Benjamin, and death – the ultimate ending to narrative – is the leitmotif of the objects discussed in this chapter.

With the rise and flowering of the realist novel in the eighteenth and nineteenth centuries, narratives became complex descriptions of the human condition. At the macro level they explore the great sweep of history (Dickens' *A Tale of Two Cities*, for example, or Tolstoy's *War and Peace*) but on a more intimate plane they deal with the materiality of daily living (such as Thackeray's novel of social aspiration, *Vanity Fair*). What these novels share is a forensic exactitude when describing the exterior appearance of the world and presenting these descriptions as metaphors for the human condition. Narrative forms, however, were transformed at the turn of the nineteenth and twentieth centuries by a new interest in internal, psychological landscapes. A key factor was the rise of psychoanalysis as a tool to explore the mind, and central to this exploration were the writings and theories of Freud, who believed the answers to understanding ourselves lay in our memories of past experiences. In his book *Death, Desire and Loss in Western Culture* (1998), Jonathan Dollimore charts the relationship of death, art and psychology and concludes that 'within psychoanalysis, the narrative of human desire riven by loss is unfolded in a dramatically expanded domain of human interiority.'[3] It is our inner lives and our awareness of loss that inform the objects in this chapter.

Freud was concerned only with the human psyche and our abilities to store memory, but designed objects are containers for memory, too. Caroline Evans has likened the processes of psychoanalysis to those of archaeology as both uncover the past and try to make sense of it in terms of the present. Maxim Velcovsky's *Catastrophe* vases look as though they have just been exhumed from an archaeological site (plate 5). They are brutal, even ugly, and appear to be covered in earth and detritus as though

they have survived a natural or manmade calamity; an earthquake, a landslide or an explosion. Similarly, the *Storm* chair (plate 58) by British furniture designer Stephen Richards looks as if it has been captured at the moment of explosion, or collapse. Its agitated form, tense angles and brittle character could stand as a metaphor for an anxious mental state. These objects seem to record their own end, or presage it.

Freud developed his notion of the death drive during the First World War. The horrors of wartime provided a context that linked melancholia, and the sense of loss experienced in the face of the futile transience of life, to a desire for death. For Freud, the most primary instinct of all is the urge to die, the urge to return to an inanimate state. Life becomes merely a detour to death, or as Freud succinctly put it, 'the aim of

58. *Storm* chair, 2000
Stephen Richards

all life is death'. Dollimore finds similarities in works by earlier writers, for example this passage from *An Anatomie of the World* (1611), written by John Donne 300 years before:

> We seem ambitious, God's work to undo;
> Of nothing he made us, and we strive too,
> To bring ourselves to nothing back ...[4]

Dollimore goes on to explain that the notion of undoing God's work relates to primal narratives of creation and destruction, good and evil, and the judgement of sin. Freud's analysis developed from Schopenhauer's views, and ultimately from

Empedocles' theory of the conflict between *philia* and *neikos* — 'love' and 'strife'. The seventeenth-century writer William Drummond knew that death was 'an inward cause of a necessary dissolution' of life; the Renaissance scholar Montaigne contended that 'the goal of our career is death. It is the necessary object of our aim'; Hamlet longed 'to die, to sleep, perchance to dream'.[5] They all shared the realization that, as Dollimore emphatically puts it, 'death is not simply the termination of life, but life's driving force, its animating, dynamic force'. He thus concludes that 'Freud's account of the death drive is a mythology of civilization, indeed the world, even of the universe; it does, after all, purport to describe nothing less than the origin of life and death.'[6]

59. *Lasting Void* stool, 2007
Julia Lohmann

Critics of Freud now dismiss the veracity of his death drive theory, but the designers in this chapter reveal a preoccupation with the meaning of death that still permeates Western culture, and objects pertaining to mortality retain the ability to stop us in our tracks. One such object is *Lasting Void* (plate 59), a resin and fibreglass stool cast by Julia Lohmann from the internal cavity of a dead calf. It has the animalistic immediacy of work by Damien Hirst, combined with the elegiac quality of a Rachel Whiteread cast. Like the *Cow* benches, it draws our attention to the animal origins of everyday artefacts and commodities, such as processed food, many of which seem very distant from the animals themselves. Although the stool was made as an edition of 12, and presented like an artwork in a Parisian gallery, Lohmann contests that 'my

subject is not art. I am concerned with design and its material origins.'[7] She regards design as ongoing research, but it is research that deeply offended and disturbed the Italian designer Alessandro Mendini. He wrote of her work:

> I can see no theoretical, aesthetic, methodological or anthropological reason which justifies the idea of immortalising a dead animal's last breath, in order sadistically to propose it as an item for everyday use, directly expressed in its suffering. The idea is cynical and pointless, it is simply turning the torture of a dead body into entertainment. Sometimes, in the field of art, the epic sacrifice of an animal expresses the mythology of the most ancient human violence and can be transformed into language, into a denouncement and a representation ... Perhaps Julia Lohmann is expressing a love for animals, but it is the demonstration of a cruel love that I cannot understand.[8]

In my view Mendini is wrong to suggest that Lohmann has turned the torture of a dead body into entertainment, an accusation more applicable to the 'plastination' of human corpses by Gunther von Hagens for his *Body Worlds* touring exhibitions (1995 and after). Mendini accurately records the impact Lohmann's work makes, but inaccurately determines that works of design are less well equipped than fine art to make profound statements about life and death. Lohmann countered this herself by saying, 'Design has to be more than merely "pleasant". Our lives are increasingly mediated through objects and revolve around consumption. It is the responsibility of the designer to embed in objects an added emotional and ethical functionality. Design should stop us from becoming numb to the world and instead prompt us to rethink how we lead our lives.'[9] Lohmann appropriates the role of modern artists as independent mediators and commentators on the human condition. As humans, is it not our unique gift and curse to be able to objectify death, our own as well as that of others? Through this and other works, including lamps made from the stomachs of sheep, Lohmann not only tackles themes normally reserved for art and religion, but also creates objects that straddle the formal boundaries between function and contemplation, product design and conceptual art.

In 2006 Studio Job designed the *Perished* collection, comprising a folding screen, a table, a pedestal and a high-backed bench (plate 60), each in an edition of six. The forms are very simple and rectilinear, while the large wings on the bench give it the suggestion of a triptych altarpiece. Each piece was veneered in rich macassar ebony like the furniture made by Émile-Jacques Ruhlmann and other Art Deco design-ers during the 1920s. Into this ground Studio Job set laser-cut bird's-eye maple inlays in the form of animal and bird skeletons. These recall both the human skeletons depicted in memento mori, and the scientific and analytic tradition of biological illustration. Memento mori were intended to foster morality and uprightness in life by reminding viewers of their own mortality, but here the religious purpose of memento mori is undercut by the Darwinian imagery of primate skeletons, suggest-ing an alternative, evolutionary sense of life and mortality. Alternatively, the title

60. *Perished* bench, 2006
Studio Job

'Perished' may refer to the near-extinct status of some of the creatures depicted, in which case these objects remind us not of our own death but of our capacity for it, rather like Lohmann's benches. The designers are ambivalent about their intentions: 'Through the skeletons, violent and innocent, their direct graphic forms depict our times which are extravagant and violent. Ours is a story uniting past and future, combining fiction and reality.'[10]

A Puritan preacher, Cotton Mather, writing in *Death Made Easie & Happy* (1701), urged the reader always to keep in mind 'that he is to die shortly. Let us look upon everything as a sort of Death's-Head set before us, with a Memento mortis written upon it.'[11] The urge to find reminders of death in everything persists. Memento mori have been a potent source of inspiration for fashion since the 1990s, notably in the collections of Alexander McQueen and Boudicca, and also fine art, for example in the work of Marc Quinn and Damien Hirst.[12] By sharing this interest, these furniture

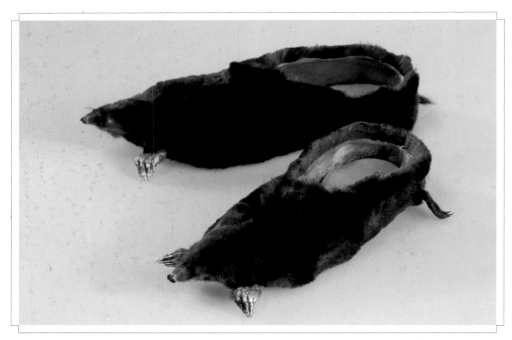

61. *Moulded Mole* slippers, 2004
Niels van Eijk and Miriam van der Lubbe

designers suggest that we are equally able to reflect on the brevity of life through the design of a chair as we are through a sculpture or the hang of a dress.

Other design belief systems are questioned in a project by Miriam van der Lubbe and Niels van Eijk of 2004 entitled *Underdogma*. Fur is a contested material in both fashion and design. The designers' response was to make a pair of slippers from discarded moleskins (plate 61). An active mole catcher might dispatch up to 500 moles in a day, the moles' carcases being regarded as waste, but in a different context they regain value. Like the work of Lohmann, the slippers record and celebrate the life – and death – of the creatures that went into their making.

The slippers reflect a renewed interest in taxidermy in art and design. Hirst's pickled shark, properly known as *The Physical Impossibility of Death in the Mind of Someone Living* (1991), is arguably the most famous artwork to comment on mortality through taxidermy. But there are many others. Since 2003 the Dutch duo Afke Golsteijn and Floris Bakker, working under the name of Idiots, have combined preserved animals with beading and jewellery techniques to create hybrid objects at the intersection of fashion, jewellery and sculpture. The objects are necessarily unique pieces, and are often small in scale. However, their most ambitious piece, *Ophelia* (plate 62), is much larger: a sleeping lioness from whose torso spews golden blobs made of ceramic and glass. The designers claim their work gives a contemporary touch to the memento mori concept by 'questioning the way the world nowadays seems to be determined by nothing else than just marketing', achieved by using the 'lens of critical fantasy'.[13] What this all adds up to is unclear, in theoretical terms, yet the transformation of familiar but disembowelled creatures into fantasy creations forces viewers to reconsider their reactions to life and death.

62. *Ophelia*, 2005
Idiots

London-based, Canadian-born Kelly McCallum, who graduated from the goldsmithing course at the Royal College of Art in 2006, also blends story-telling and natural history in her work, combining precious metals with taxidermy. Her logic is clear. 'Taxidermy seeks to preserve life by celebrating death,' she writes. 'It is a strange half life, a suspension, an illusion.'[14] Her works include stuffed birds and small dogs that bleed ruby-coloured crystals, or bare suppurating wounds of gilded maggots (see page 92). There is a tension between revulsion and attraction that arises from her precious rendering of shocking matter, and these ambiguities contribute to the unnatural character of the objects. McCallum generally uses old taxidermy, often Victorian, as she appreciates that these objects had a pre-history before they reached her: they have their own stories as well as the tales she suggests by embellishing them. Although her objects are seldom wearable, her practice is based in goldsmithing or

jewellery-making and this is where she tends to site her work. All these objects owe debts to Surrealism (as did the couture designs of Elsa Schiaparelli, for example) and to religious art, such as images of Christ or the Madonna revealing bleeding hearts.

The Lovers rug by London-based design practice Fredrikson Stallard (Patrik Fredrikson and Ian Stallard) is another memento mori, inasmuch as it reminds us of our bodies' visceral nature. Formed as a pair of conjoined pools of freely poured urethane, it represents the average quantity of blood in two people. According to Fredrikson Stallard, 'The meaning of beauty is crucified and literally laid bare.'[15] The Ancients believed that blood is the seat of the emotions and so denotes love, but shed blood indicates death: life and loss are intertwined in this object. It can be compared to Quinn's *Self* (1991), a frozen sculpture of the artist's head made from his own blood, an entire bodyful taken over a period of five months. Temporal concerns appear elsewhere in the work of Fredrikson Stallard, for example the free-form Rubber table (2007), made in flesh-coloured polyurethane resembling a huge slab of meat. The

63. Aluminium table, 2007
Fredrikson Stallard

designers are interested in representing psychological as well as physical reality. Their series of aluminium tables (plate 63), designed in 2007, is based on enlarged abstract ink-blot prints from Rorschach tests, which had been developed in 1921 by the Swiss doctor Hermann Rorschach as a technique of psychodiagnosis. Fredrikson Stallard use the device both structurally and decoratively, but they do not suggest interpretations of it. Nor are we invited to read psychological meanings into it.

There is something very visceral about the *Morse* light (plate 64), designed by the London-based studio rAndom International (Stuart Wood, Flo Ortkrass and Hannes Koch). Its 65 metres of capillary tube, through which coloured liquid is pumped, suggest the form of a dialysis machine. The liquid flows in a sequence of dots and dashes, a 'morse code' passing through the tube that encircles a lamp in a glass bowl. As the liquid is pumped, it creates the effect of writhing motion. The designers compare the work to an ants' nest, but it appears equally like a bowl of maggots. 'Where does

64. *Morse* light, 2006
rAndom International

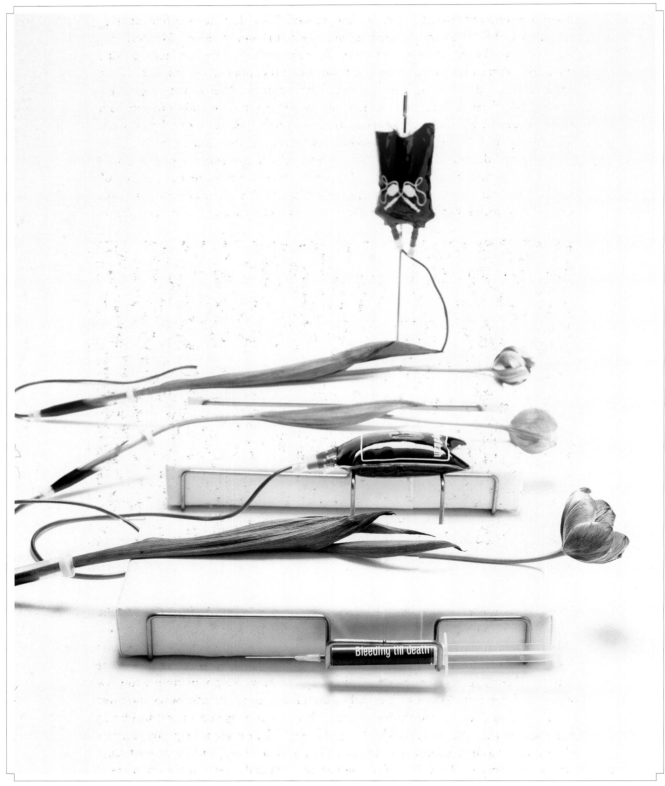

65. *Bleeding Till Death*, 2005
Hilde Koenders

decoration end and disgust start?', the designers ask.[16] The circulatory system analogy also informed Hilde Koenders' graduation project at Design Academy Eindhoven in 2005, entitled *Bleeding Till Death* (plate 65). Her vase took the form of medical drips, intended to arrest the death of the cut flowers that it contained, which visibly drew red liquid, like blood, along their stems and into their petals. It was an elegiac representation of death. Neither Koenders' nor rAndom International's projects have been editioned and they remain as prototypes. Nevertheless, they both demonstrate a prevailing spirit in design that is concerned with representing mortality.

Decay and decline characterize these works, which also contain an element of decadence. Wieki Somers designed the *High Tea Pot* (plate 66), modelled on a pig's skull with a water-rat fur tea cosy, for a project entitled *Deliciously Decadent* (2003), initiated by the Het Princessehof National Ceramic Museum in Leeuwarden, the Netherlands.

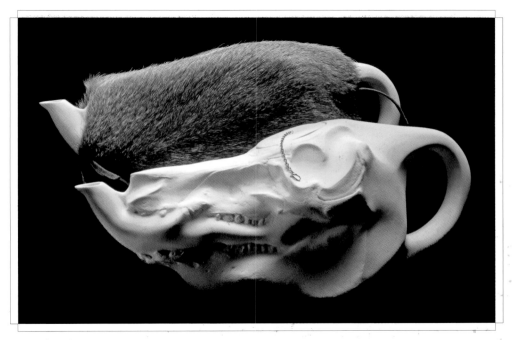

66. *High Tea Pot*, 2003
Wieki Somers

She defines decadence as 'where the tasty and the unsavoury, the harmful and the delightful are no longer discernible from one another'.[17] As with much conceptual Dutch design, it achieves its impact by contrasting two extremes, in this instance the bestial, symbolized by the pig and the rat, and the civilized, signified by the polite activity of drinking tea. Animals are frequently evoked in design, or supply the raw materials for production, but are usually used for their symbolic attributes and most often for their decorative qualities. Somers' choice of the pig and the rat heightens the contrast with the act of tea-drinking because of their evident inappropriateness (like a boar in a china shop, a literal twist on a familiar analogy), but the impact relies on a commonly held revulsion for these animals. Equally, tea-drinking is Somers'

shorthand for everything that is polite, bourgeois, civilized and therefore human. At both extremes she relies on her viewers sharing and understanding her code to appreciate fully her design.

Other conceptual designers, who also explore the role of design in shaping our world and often ponder the darker aspects of experience, include the London-based duo Dunne & Raby (Anthony Dunne and Fiona Raby). Primarily design theorists, their collections are posited as research projects, rather than prototype products for mass manufacture or artworks, yet they share ground with both types of production. Sometimes made in small editions, they often critique existing technologies or the functionality of products. One such research project is *Designs for Fragile Personalities in Anxious Times* (2004), produced in collaboration with industrial designer Michael Anastassiades, which responds to our fears about abduction, war and malaise in the new millennium. The centrepieces of the project are three objects

67. *Hide Away Furniture*, 2004
Dunne & Raby with Michael Anastassiades

collectively called *Hide Away Furniture*, which appear to grow out of the floorboards (plate 67). Camouflaged as extensions of the floor surface, they act as undetectable safe havens, individual panic rooms to which the anxious can retreat when under threat. The objects are lined with felt for comfort and sound insulation, and each forces the occupant to assume a particular pose adopted from recumbent figures in various well-known paintings, including Manet's *Olympia* (1863), which are intended to make the user feel at ease, assertive and in control. But there is no escaping their visual similarity to wooden boxes of a more conclusive kind. A satirical 1828 print by Thomas Jones, entitled *A Grave Idea* (plate 68), shows a skeleton holding a coffin to which is

68. *A Grave Idea*, 1828
Thomas Jones (active 1820–40)

attached the notice 'An Apartment for a SINGLE Gentleman'. This early nineteenth-century memento mori confronts our fear of death with more humour, but no less directly, than our twenty-first-century example. The designers may have conceived the work as a series of shelters rather than graves, but comparison is inevitable.

Hide Away Furniture also has links with *Sensory Deprivation Skull* (plate 69), designed by Joep van Lieshout, whose work genuinely intersects the boundaries of fine art, design and architecture. The large, often dystopian installations that he constructs in his favoured material of fibreglass are set within a fictional civilization, known as Slave

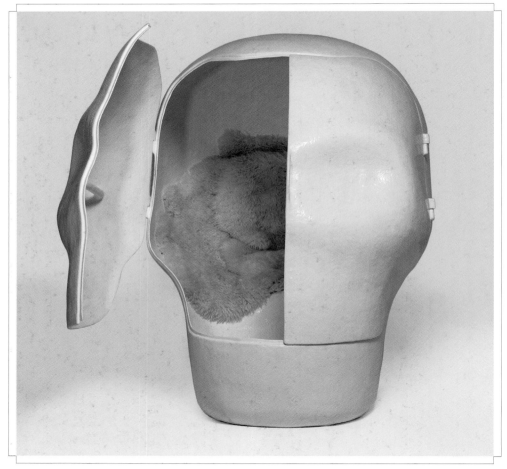

69. *Sensory Deprivation Skull*, 2007
Joep van Lieshout

City, and provide a means of examining the human condition.[18] His sensory deprivation chamber in the form of a human skull, lined in fur, can accommodate two people. It is a literal analogy for Freudian psychoanalytical exploration as it allows you to 'get inside your head', while the fur, and the possibility of company in the cramped, darkened chamber, raise erotic possibilities that Freud, whose interests lay in unconscious sexual feelings, may have appreciated.

Alongside *Hide Away Furniture*, *Designs for Fragile Personalities in Anxious Times* features soft toys, or cushions, shaped like mushroom clouds from nuclear explosions (plate 70). Each is named after a particular test explosion, for example, 'Priscilla 37 kilotons Nevada 1957'. These devices are intended to diffuse our horror of nuclear annihilation by allowing us to approach, even literally to embrace, our fears, which are not only named and dated but also horrifyingly humanized. At the same time we are infantilized, as the nuclear subject is made into a child's object. The soft toys are therefore intended as psychological prostheses that use humour and liberal doses of

70. 'Priscilla 37 kilotons Nevada 1957', *Designs for Fragile Personalities in Anxious Times*, 2003
Dunne & Raby with Michael Anastassiades

irony to help us confront what may at first seem impossible to face: the threat of total nuclear desolation.

Boym Partners use the same strategy for their collectible miniature monuments, known as the *Buildings of Disaster* (see plates 1, 2 and 71). Constantin Boym compares the series to the mushroom-cloud cushions: 'In my case, the irony is buried deeper in the object: some people perceive it more than others. It should not be overly clear where

"the author" stands; there has to be room for people to put in their own interpretations."[19] Such works, while being psychological 'containers' into which we can offload and store our anxieties, are also, in another sense, fetishes because they represent intangible emotions in concrete form. Boym Partners initiated the series as a response to the Oklahoma bombing in 1995 and saw it as a reflection 'on our past (tragic) century [seen] through the prism of disaster, which in our media-obsessed time became a measure of history itself'.[20]

These 'souvenir ornaments' are made in editions of 500, rather like Franklin Mint collectibles, but are deliberately banal representations of buildings and sites where disasters have occurred in recent history. Whereas conventional souvenirs and ornaments idealize reality, ironically these geegaws depict destruction, desolation and

71. 'Chernobyl', *Buildings of Disaster*, 1995 to present
Boym Partners

death. Commemorative subjects include the nuclear power plants at Chernobyl (plate 71) and Three Mile Island (plate 2), where industrial accidents threatened the lives of millions, and the Alma Tunnel in Paris, the site of the car crash that killed Princess Diana and Dodi Al Fayed in 1997. This latter, individual tragedy became the focus for mass mourning, in itself a testament to how we project our psychological needs onto events and places. Most poignantly, the *Buildings of Disaster* include models of both the Pentagon and the World Trade Center (plate 1), commemorating the events of September 11. Boym Partners were initially reluctant to introduce these models to the series, especially since – as residents of south Manhattan – they were

directly affected, but they ceded to the swell of demand. The models instantly became a focus for grieving and commemoration; some were purchased by former workers in the towers and even those whose offices had been destroyed in the disaster. Boym Partners recognized 'an overwhelming need for a mnemonic device, an object where people could put their feelings and make their memory permanent'.[21]

The banality of the models is the key to their success because they allow us to face the horrors of events beyond our control in a far less emotive way than the precise, realistic depictions in, say, photographs of the burning buildings. Yet these models retain a force that derives from the shared cultural values they represent. The Chapman brothers sometimes ironically contrast banality and horror in their art, for example, *Insult to Injury, the marriage of reason and squalor* (plate 72), in which they

72. From the *Insult to Injury* series, 2003
Jake and Dinos Chapman

'embellished' an edition of some 80 early-twentieth-century prints of Goya's *Disasters of War* (1810–20), adding ghoulish clown and cartoon faces to some of the characters. Their interventions contributed to a heightened sense of the inhumanity and cruelty of the historical event depicted by Goya – the Napoleonic invasion of Spain in 1808 – allowing us to approach them anew. Robert Hughes wrote, 'We see [Goya's] face pressed to the glass of our terrible century, mouthing to make his warnings understood'.[22] But Jake Chapman adds, 'We cannot hear Goya's words and cannot learn from our mistakes – we can only denounce the violence we are condemned to repeat.'[23] The repetitiveness of the 20 or so models in the on-going *Buildings of Disaster*

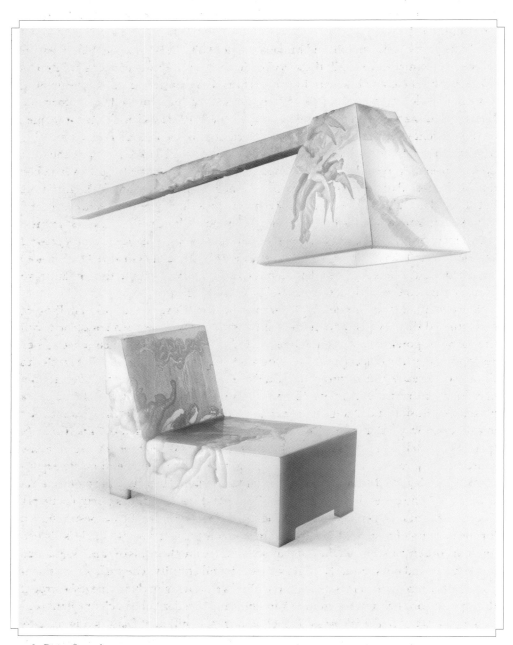

73. *La Divina Commedia*, 2008
Niels van Eijk and Miriam van der Lubbe

series remind us of the continuing violence of our times. One collector articulated their meaning to him: 'When we visit the Eiffel Tower we can leave with a keepsake, a golden Eiffel Tower in a snowball. When we turn the TV off, no snowball from Chernobyl will decorate the fireplace. Nothing to remember the images of the catastrophe, the dead. It's this emptiness that Constantin Boym wants to fill with his small objects.'[24]

To designers Niels van Eijk and Miriam van der Lubbe, *The Divine Comedy* represents the most essential story of all; the story of life and death. The epic poem, written by Dante between 1308 and his death in 1321, has long been considered one of the greatest works of world literature. It tells of Dante's journey through Hell, Purgatory and Heaven, and is an allegorical representation of the Christian afterlife. Accompanied by the Ancient Greek poet Virgil, he enters Hell on the eve of Good Friday, emerging in Purgatory on Easter Sunday, thus turning the tale into a representation of the solar cycle as well as a metaphor for the resurrection. The work was largely overlooked during the period of the Enlightenment with the notable exception of William Blake, but it was later championed by the Romantic writers of the nineteenth century. Twentieth-century writing, by Modernist poets and authors with an interest in mysticism including T.S. Eliot and Samuel Beckett, shows its influence. Dante's graphic descriptions influenced many visual artists, too, most notably Gustave Doré, whose engraved illustrations completed between 1857 and 1868 owe more to the romanticism of Blake than to the medieval context of Dante's world view.

Since Van Eijk and Van der Lubbe graduated from Design Academy Eindhoven, and founded their own studio in 1998, much of their work has been concerned with the narrative potential of design. When pressed on the meaning of their objects, they respond, 'They [the objects] try to tell you a different truth. They will always refer to things you already know from your past, like a material use, a pattern, a decoration, or a function or use. But they will give you something new as well. They cause a pleasant confusion and change your perspective to things and challenge you to look in a different way [at] the world around you.'[25] Their work entitled *La Divina Commedia* (plate 73), which comprises a chair and a lamp, contains references to their many sources of inspiration: 'Behaviour of people. References to non-mentionable experiences. Everyday life. Machinery. Production techniques. History.'[26] Both objects are decorated with scenes derived from Doré's illustrations of Dante's poem (plate 75). The eighth and ninth circles of hell, as described by Dante, are the deepest, reserved for those guilty of treachery and deliberate, knowing evil. The eighth circle is divided into ten concentric stone ditches, and in one of these are the souls of thieves, guarded by a centaur and pursued and bitten by snakes for all eternity. The snakes are a metaphor for the reptilian secrecy of theft. It is Doré's engraving of these thieves' torment that appears on the lower portion of Van Eijk's and Van der Lubbe's chair (plate 74).

The impact of *La Divina Commedia* relies on our recognition of Dante's original tale, part of the fabric of Western culture, and of Doré's engraved representation of it. But these sources have been manipulated so we see them with fresh eyes. Further disjuncture is provided by the means that the designers have employed. The chair and lamp are both made from thick white polypropylene sheet, which has a luminous quality

that resembles marble. Van Eijk and Van der Lubbe have laser-engraved enlarged sections of Doré's illustrations onto these forms, wrapping the two-dimensional images around edges and corners. Modern synthetic materials and digital techniques married to historical content is an approach we have encountered frequently in this book, for example in the work of Jeroen Verhoeven, and the 'pleasant confusion' that arises from the disjuncture of materials and style is characteristic of the narrative approach adopted since the early 1990s by Dutch designers.

Like the works produced by Meta, *La Divina Commedia* is the result of a partnership between avant-garde designers and highly skilled artisans. The combination of flat, engraved surface pattern merging into relief carving is a technique the designers used

74. *La Divina Commedia* chaise longue (detail), 2008
Niels van Eijk and Miriam van der Lubbe

for a previous work, *Godogan* (2006). This comprised a table, made by Indonesian crafts-men, which featured a highly complex computer-rendered pattern of tadpoles and frogs in a lily pond, inspired by an Indonesian fairy tale about a frog (or *godogan*) that turns into a prince. The purpose of the table, which was presented by Droog Design and New York's Friedman Gallery at the 2006 Art Basel/Miami Art Fair, was to empha-size the level of craftsmanship it is possible to commission in the Far East, where such skills are generally exploited as cheap labour. High quality craftsmanship, according to Van Eijk and Van der Lubbe, is scarce in the West, making the products that utilize

it necessarily expensive and exclusive. *La Divina Commedia* demonstrates the craft skills of Belgian carver Donaat van Overschelde, who over-carved some parts of the engravings in shallow bas-relief. As this work is not intended to be mass-produced, and will only ever exist in a small 'design art' edition, the designers' point about the exclusivity of craftsmanship is revisited.

Suspended above the chair is a monumental lamp, not dissimilar in form to an enormous axe, hanging like some divine judgement. It is decorated with extracts from a second Doré illustration, which shows the angels that supported Christ on the cross. Dante described God as a point of light, represented here by the light source of the lamp. In Hell, the bodies of the thieves writhe below our sight line while above

75. *Thieves*, illustration for canto XXIV, of Dante's *The Divine Comedy*, c.1872
Gustave Doré (1832–1883)

us, floating in light, is Heaven. The designers have chosen not to represent Dante's Purgatory, but perhaps this state is embodied by anyone bold enough to sit on the chair, metaphorically inserting themselves between Heaven and Hell.

Presented together, these objects are contemporary representations of both Dante's and Doré's stories, and their peculiar proportions – particularly that of the massive, counter-balanced lamp – lead us to regard *La Divina Commedia* as a sculpture for contemplation rather than functional furniture. Yet function lies at the heart of the designers' purpose, and when asked if they make art objects or design works they

reply (somewhat cryptically), 'Design. They are always products, but they can differ in an object way of approach or a product way of approach.'[27]

Doré's engravings owe much to Blake and Romanticism but the naked forms in dramatic poses also suggest Baroque art of the sixteenth and seventeenth centuries, as referenced by *Damned.MGX* (plate 76), a chandelier by another Dutch designer, the architect Luc Merx. It grew out of a research project called *Rococorelevance* (2002), in which the architect sought contemporary applications for Rococo decorative details, including motifs reproduced and multiplied by computer. For this chandelier, Merx took inspiration from art of the sixteenth and seventeenth centuries, the sculpture of Bernini and Giambologna, and specifically *The Fall of the Damned*, painted by Rubens in 1621, now in the Alte Pinakothek, Munich (plate 77). Rubens' painting, like Doré's

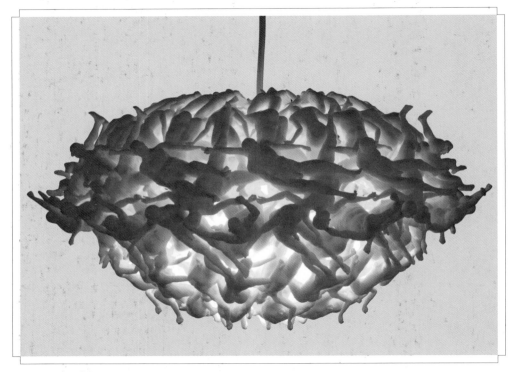

76. *Damned.MGX* chandelier, 2007
Luc Merx

engravings, shows fallen and falling souls. Common to all these artists is a realistic representation of the human body, often naked, and often as a metaphor for spiritual attributes. Representations of the human body lie at the heart of the Western tradition of art and by applying them to a work of design, Merx seems implicitly to equate the value of design and art.

The chandelier appears as a cloud of about 170 weightless, tumbling human figures, of which there are 16 or 17 types. Inspired by Baroque art, the lamp none-the-less remains a functional design. It is made in an edition of 30 by Materialise, a Belgian firm specializing in rapid prototyping technology. The publicity statement

77. The Fall of the Damned, 1621
Peter Paul Rubens (1577—1640)

for the chandelier expounds upon the designer's intentions: 'He imagines the lamp hanging above a dining table, the shock of the frozen bodies disturbing diners with age-old questions of guilt and morality, issues usually kept behind closed doors.'[28] To these age-old questions we might add mortality, too.

Not only is the chandelier designed on computer, it is also made entirely by computer-controlled technology: selective laser sintering, a type of three-dimensional printing popular as a means of quickly making prototypes during the industrial design process. The technology is expensive but it is used increasingly by designers to create finished objects, the first having been Ron Arad (1999). Its advantage over other modelling technologies, such as the casting of ceramics or the moulding of plastics, is that very complex forms can be produced in a single process without the need to assemble components. A cut-through rendering of the chandelier (plate 78) shows that it is constructed from layers of body forms that surround the light source. The manufacturer's publicity statement reads, 'The lamp is a masterpiece of virtuosity, similar to that of eighteenth-century ivory furniture. But the difference is that this is not the result of our virtuosity, but that of the computer.'[29] Both the design and fabrication processes require considerable skill; skill that can be compared with traditional craft-based techniques, for example the enamelling of the leaves that clad Tord Boontje's *Fig Leaf* wardrobe. Rapid-prototyping technologies hold the promise of endless mechanical reproduction, but the handcrafted skills of the enamellers impose a limit on the number of products they can make. The scarcity of both rapid-prototyping facilities and hand-enamelling means that neither technology can be used for mass production today and its cost means that anything made using these techniques is necessarily expensive. While the sheer lack of available craftsmanship will naturally cap the number of *Fig Leaf* wardrobes Meta anticipates can be made, Merx and Materialise have artificially capped production of *The Fall of the Damned*, a figure being arbitrarily chosen because digital technology imposes no inbuilt restriction. It is therefore presented not as a prototype for industrial production but as an exclusive product. Moreover, it is an exclusive product that makes claims for both its technical virtuosity and its artistic message. Merx comments that 'first and foremost it is just a lampshade, but when you look more closely it gains meaning. Just calling something "art" isn't enough to give it meaning. This is something between art and design.'[30] In short, *The Fall of the Damned* is a model for 'design art'.

Explorations of Freud's death drive and psychoanalytic excursions into the human psyche may seem to sit uncomfortably with the spiritualism of the *The Divine Comedy* or God's judgement portrayed in Baroque art. Yet they are all different expressions of our own self-knowledge, especially our understanding that we are part of larger natural or spiritual schemes. The fourteenth-century mystic Julian of Norwich described a benevolent God and preached acceptance of, rather than resistance to, the inevitable. 'All shall be well, and all shall be well, and all manner of thing shall be well,' she wrote. T.S. Eliot, greatly influenced by both religious mysticism and, like Freud, the horrors of modernity, used her words in 'Little Gidding', the last of his *Four Quartets*. Similarly, Eliot explored the 'dark night of the soul' described by the sixteenth-century Spanish mystic St John of the Cross. This is a metaphor for the

78. *Damned.MGX* chandelier (computer rendering), 2007
Luc Merx

journey of a soul seeking union with God, but equally it is a metaphor for the pain of achieving maturity and detachment from the world. Anxiety and loss are painful parts of this process and a number of the works in *Telling Tales* represent designers' responses to these themes.

* * *

Stories invest objects with meaning, giving them voices, histories and personalities. Moreover, if we choose to tell our personal stories through objects, they gain our own meanings alongside those of the designer. Many of the objects shown here refer to the great universal narratives of life, death and renewal that are woven into our cultural memory, familiar from myth and fairy tale, religion, and even our own hidden desires. In 'The Forest Glade', the first chapter of *Telling Tales*, the designs recall a state of innocence that is analogous with both spiritual birth and childhood, and which owes much to the fairy tales and creation myths that form the backbone of narrative. In 'The Enchanted Castle', innocence has turned to guilt, and the designs parody worldliness, wealth and status. 'Heaven and Hell' stands somewhat apart, reflecting on judgement and the state to which the first two chapters may bring us. We may also consider whether the subject of 'design art' itself is to be judged; whether it is innocent or guilty of manipulating the media and markets or whether it genuinely represents a new, creative path for designers. These are works by a genera-tion of designers who are dissatisfied with only operating as design-managers, stylists or prototypers for industry. They are drawing upon fine art modes of practice and distribution of works but do not cast themselves as artists. Rather, they inhabit a new place, between the conventional boundaries of art, craft and design, where their eloquent works can speak of the human condition.

NOTES AND FURTHER READING

INTRODUCTION

1 Jurgen Bey, artist statement, Contrasts Gallery, Shanghai, www.contrastsgallery.com, (March 2008).
2 Victor Turner, 'Social Dramas and Stories about Them', in W.J.T. Mitchell (ed.), *On Narrative*, Chicago, 1981, p.163.
3 Walter Benjamin, 'The Storyteller', in H. Arendt (ed.), *Illuminations*, 1936, translated by Harry Zohn, London, 1970, p.83.
4 Ibid, p.91.
5 Louise Schouwenberg, 'A conversation with Hella Jongerius that might have taken place', www.jongeriuslab.com, 2003; an abbreviated version is reprinted in Alex Coles (ed.), *Design and Art*, London / Cambridge Mass., 2007, pp.89–93.
6 Benjamin, 'The Storyteller', p.108.
7 Caroline Evans, *Fashion at the Edge*, New Haven / London, 2003, p.54.
8 Maxim Velcovsky, artist statement, September 2007, supplied by Mint, London.
9 Peter Gay, *The Naked Heart; The Bourgeois Experience, Victoria to Freud*, London, 1995.
10 For more about the relationship of craft to art, see Glenn Adamson, *Thinking Through Craft*, Oxford / New York, 2007.
11 Walter Gropius, in *The New Architecture and the Bauhaus*, 1935, put forward the idea of the architect as co-ordinator, which directly leads into the notion of the designer as manager. For more on Gropius, see Mark Wigley, 'Whatever Happened to Total Design?', *Harvard Design Magazine*, no.5, summer 1998, reprinted in Alex Coles, *Design and Art*, 2007, pp.157–71. In his 1969 essay 'Is a Designer an Artist?', Norman Potter concludes that the designer's process is collaborative, discursive, problem-solving, subservient and managerial. Norman Potter, *What is a Designer*, London / New York, 1969, revised extended edition, London, 1989/2003, pp.15–20; reprinted as 'Is a Designer an Artist?' in Alex Coles, *Design and Art*, pp.29–33.
12 Donald Judd, 'It's hard to find a good lamp', *Donald Judd Furniture Retrospective*, Rotterdam / Munich, 1993, pp.7–21; reprinted in Alex Coles, *Design and Art*, pp.50–54/50.
13 An example of how the craft and contemporary art camps have drawn closer together was the V&A / Crafts Council exhibition *Out of the Ordinary, Spectacular Craft*, 12 November 2007 – 17 February 2008.
14 Mike Featherstone introduced this useful term in *Consumer Culture and Postmodernism*, London, 1991.
15 Paul Rand, 'Politics of Design', *Graphis Annual*, Zurich, 1981, pp.233–5; reprinted in Alex Coles, *Design and Art*, pp.34–7.
16 Virginia Postrel, *The Substance of Style: How the Rise of Aesthetic Value is Remaking Commerce*, New York, 2004. The modern use of styling to stimulate sales of products has origins in 1930s American design.
17 Job Smeets, quoted by Alex Wilshire in *Icon*, no.19, January 2005.
18 Vilém Flusser, 'About the Word Design', Chicago, 1993, reprinted in Alex Coles, *Design and Art*, pp.55–7.
19 For a more detailed examination of the role of design galleries see a conversation between Pierre Staudenmeyer (founder of the galleries Neotu and Mouvements Modernes, Paris) and Didier Krzentowski (Gallerie Kreo, Paris), 'Design Playing to the Gallery', *Intramuros*, no.118, May/June 2005, pp.65/144.
20 See Lesley Jackson and Marcus Fairs, 'Design is the new art', *Icon*, no.33, March 2006, pp.46–9.
21 Quoted in Mark Rappolt, 'What is "design art"?', *Art Review*, December 2007, pp.88–9.
22 Ibid.
23 Holdeman and Gill, both quoted in Brook S. Mason, 'Price rise as big players come on board', *The Art Newspaper*, Design Focus supplement, June 2008.
24 I have written about the role of manifestos in the sphere of the design avant-garde, notably the force of manifestos in recent Dutch design (although it is no longer confined only to a Dutch design approach). See Gareth Williams, *The Furniture Machine: Furniture Since 1990*, London, 2006, chapter five, 'Design Manifestos'.
25 I am grateful to Glenn Adamson for suggesting this distinction between Postmodern design and contemporary design.

THE FOREST GLADE

1 Angela Carter, 'Penetrating the Heart of the Forest', in *Fireworks, 9 Profane Pieces*, London, 1974.
2 Harold Bayley, *The Lost Language of Symbolism*, 1912, London, 1951 edition, vol.1, p.177.
3 More recent literature includes Neil Phillip, *The Cinderella Story: the origins and variations of the story known as 'Cinderella'*, London, 1989.
4 Jack Zipes, *When Dreams Came True: classical fairy tales and their tradition*, 1999, second edition, New York / London, 2007, p.2.
5 Ibid, p.13.
6 Ibid, p.16; Marina Warner, *From the Beast to the Blonde: on fairy tales and their tellers*, London, 1994, p.xiii.
7 Nadja Swarovski, quoted in Martina Margetts, *Tord Boontje*, New York, 2006, p.128.
8 Conversation with author, Bourg-Argental, France, 21 May 2008.
9 G.R. Batho, 'Victorian Master of Wood-Carving', *Country Life*, 12 January 1961, pp.60–62.
10 Le Corbusier, *The Decorative Art of Today*, 1925, trans. James Dunnett, London, 1987, p.85.
11 For example, Magritte's painting *16ᵗʰ September* (1956) depicting a tree against a blue sky.
12 Warner, *From the Beast to the Blonde*, p.xvi.
13 Jurgen Bey, artist statement, Contrasts Gallery. See Introduction, note 1.
14 Jurgen Bey, quoted in Ineke Schwartz, 'Cracking the codes of reality, an interview with Jurgen Bey', in Ed Anninck and Ineke Schwartz (eds), *Bright Minds, Beautiful Ideas*, Amsterdam, 2003, p.176.
15 Ibid, p.182.
16 Jurgen Bey, quoted in *Couleur Locale, Droog Design for/für Oranienbaum*, Rotterdam, 1999, p.33.
17 Since 2008 the table has been made by Editions David Gill and credited to Fredrikson Stallard.
18 Correspondence with author, 24 May 2008.
19 Ibid.
20 www.studiolibertiny.com (March 2008). See also Louise Schouwenberg and Gert Staal (eds), *House of Concepts*, Design Academy Eindhoven, Amsterdam, 2008, p.300; *Icon*, no.59, May 2008, pp.66–9.
21 For a detailed discussion of the Pastoral in the modern craft movement, see Glenn Adamson, *Thinking Through Craft*, Oxford / New York, 2007, pp.103–38.
22 *The Farm* was presented at Spazio 8, Milan, by Designhuis, Eindhoven, during the Milan Furniture Fair, April 2008, before permanent installation in the Zuiderzee Museum in June 2008.
23 Correspondence with author, 18 August 2008.
24 Correspondence with author, 3 April 2008.

THE ENCHANTED CASTLE

1 E. Nesbit, *The Enchanted Castle*, London, 1907.
2 Edgar Allen Poe, *Philosophy of Furniture*, Philadelphia, 1840, vol.5 of the Raven Edition.
3 Adolf Loos, *Ornament and Crime*, Innsbruck, 1908.
4 Job Smeets, quoted by Alex Wilshire in *Icon*, no.19, January 2005.
5 See Peter Hughes, *The Wallace Collection, Catalogue of Furniture*, London, 1966, pp.809–30 for detailed descriptions of the three armoires by Boulle upon which this design is based.
6 Susan Sontag, 'Notes on Camp', 1964; published in book form in Sontag's collection of essays entitled *Against Interpretation*, 1966.
7 Publicity material for Marcel Wanders' *Personal Editions*, 2007.
8 Correspondence with author, 19 May 2008.
9 Pierre Bergé is best known as the business partner of Yves Saint Laurent. His new business venture, as an auctioneer and gallerist specializing in American design of the period 1910–70 and contemporary design, sees a further conflation of the design and fashion realms.
10 Sontag, 'Notes on Camp'.
11 Joris Laarman, quoted by Alex Wilshire in *Icon*, no.16, October 2004.
12 Correspondence with author, 19 March 2008.
13 Correspondence with author, 12 February 2008.
14 Press release for the *Layers* collection, presented at Galleria Facsimile, Milan, 16–20 April 2008.
15 Correspondence with author, 7 May 2008.
16 *Diamonds are a Girl's Best Friend 2*, also designed by Matali Crasset for the Meta collection, was a full-length dressing mirror.
17 Giles Hutchinson-Smith in Nicole Swengley, 'Contemporary with antique quality', *Financial Times* / www.ft.com, 28 March 2008.
18 See Marion S. van Aaken-Fehmers, 'Vases with Spouts, three centuries of splendour', vol. III, *Dutch Delftware, History of a National Product*, Gemeentesmuseum, The Hague, 2007; the examples in the Victoria and Albert Museum have the inventory numbers c.96–1981 and c.19–1982.
19 Ibid.
20 Artist statement issued by Royal Tichelaar Makkum, April 2008.
21 Artist statement issued by Royal Tichelaar Makkum, April 2008.
22 Sontag, 'Notes on Camp'.

HEAVEN AND HELL

1 Walter Benjamin, 'The Storyteller', in H. Arendt (ed.), *Illuminations*, 1936, translated by Harry Zohn, London, 1970, p.94.
2 Arthur Schopenhauer, quoted by Jonathan Dollimore, *Death, Desire and Loss in Western Culture*, London, 1998, p.178.
3 Ibid, p.180.
4 Ibid, p.191.
5 Ibid, pp.192–3.
6 Ibid, p.191.
7 Julia Lohmann, quoted in *Icon*, no.53, November 2007.
8 Alessandro Mendini's open letter to Didier Krzentowski of Galerie Kreo, Paris, which presented the *Lasting Void* bench, and Julia Lohmann's reply, are both published in *Icon*, no.53, November 2007, p.39.
9 Ibid.
10 Studio Job, artists' statement on the *Perished* collection, 2006.
11 Cotton Mather, *Death Made Easie & Happy*, London 1701, p.94, cited in David E. Stannard, *The Puritan Way of Death, a study in religion, culture and social change*, Oxford, 1977, pp.77–8. I am indebted to Glenn Adamson for this reference.
12 Caroline Evans, *Fashion at the Edge*, New Haven / London, 2003, p.223.
13 www.idiots.nl/news (May 2008).
14 www.kellymccallum.com/biography (May 2008). I am grateful to Janice Blackburn for suggesting McCallum's work to me.
15 www.fredriksonstallard.com (May 2008).
16 www.random-international.com/morse (December 2008).
17 Correspondence with author, 3 April 2008.
18 See Aaron Betsky and Jennifer Allen, *Atelier Van Lieshout*, Rotterdam, 2006.
19 Correspondence with author, 14 February 2008.
20 Correspondence with author, 13 February 2008.
21 Constantin Boym, *Curious Boym*, New York, 2002, p.102. A full history of the *Buildings of Disaster* collection is included here.
22 Robert Hughes, quoted in Jake and Dinos Chapman, *Insult to Injury, the marriage of reason and squalor*, London, 2003, no pagination.
23 Ibid.
24 Pascal Yanou, a collector of the *Buildings of Disaster*, quoted in Boym, *Curious Boym*, p.98.
25 Correspondence with author, 22 February 2008.
26 Ibid.
27 Ibid.
28 Publicity material for *The Fall of the Damned* chandelier, www.materialise.com (February 2008).
29 Ibid.
30 Conversation with author, 18 March 2008.

FURTHER READING

Adamson, Glenn, *Thinking Through Craft*, Oxford / New York, 2007

Allen, J. and Betsky, A., *Atelier Van Lieshout*, Rotterdam, 2006

Annink, E. and Schwarz, I. (eds), *Bright Minds, Beautiful Ideas: parallel thoughts in different times: Bruno Munari, Charles & Ray Eames, Martí Guixé and Jurgen Bey*, Amsterdam, 2003

Bal, Mieke, *Narratology: Introduction to the theory of narrative*, Toronto, second edition 1997

Bayley, Harold, *The Lost Language of Symbolism*, London, 1912, 1951

Benjamin, Walter, 'The Storyteller, Reflections on the Works of Nikolai Leskov', *Illuminations*, London, 1970

Boym, Constantin, *Curious Boym: design works*, New York, 2002

Carter, Angela, *The Bloody Chamber and Other Stories*, London, 1979

Chapman, Jake and Dinos, *Insult to Injury, the marriage of reason and squalor*, London, 2003

Coles, Alex, *DesignArt*, London, 2005

Coles, Alex (ed.), *Design and Art*, London / Cambridge Mass., 2007

Dollimore, Jonathan, *Death, Desire and Loss in Western Culture*, London, 1998

Evans, Caroline, *Fashion at the Edge*, New Haven / London, 2003

Margetts, Martina, *Tord Boontje*, New York, 2007

Mitchell, W.J.T. (ed.), *On Narrative*, Chicago, 1981

Poe, Edgar Allen, *Philosophy of Furniture*, Philadelphia, 1840

Powilleit, Inga and Quax, Tatjana, *How They Work: the hidden world of Dutch design*, Rotterdam, 2008

Schouwenberg, L. and Staal, G. (eds), *House of Concepts, Design Academy Eindhoven*, Amsterdam, 2008

Sontag, Susan, 'Notes on Camp', 1964; published in *Against Interpretation*, London, 1966

Stannard, David E. *The Puritan Way of Death, a study in religion, culture and social change*, Oxford, 1977

Van Aaken-Fehmers, Marion S., *Dutch Delftware, History of a National Product*, The Hague, 2007

Warner, Marina, *From the Beast to the Blonde: On fairytales and their tellers*, London, 1995

Zipes, Jack, *When Dreams Came True: Classical Fairy Tales and Their Tradition*, London, second edition 2007

WORKS IN THE EXHIBITION

Works are listed alphabetically by designer. Dimensions give height before width and depth, or diameter, where appropriate.

THE FOREST GLADE

Maarten Baas (b. 1978, the Netherlands)
Sculpt wardrobe, 2007 (plate 26)
Steel, walnut veneer, 250 × 145 × 60 cm
Edition of 8 (plus 2 artist proofs)
Lent by Carpenters Workshop Gallery, London

Jurgen Bey (b. 1965, the Netherlands)
Linen-Cupboard-House ('Linnenkasthuis'), 2002
(plate 21)
Found furniture, textiles, mattress, stone,
300 × 300 × 200 cm
Edition of 4 (plus one artist proof), no. 2
exhibited
Lent by Studio Makkink & Bey, the
Netherlands

Tord Boontje (b. 1968, the Netherlands)
Witch chair, 2004 (plate 13)
Metal, foam, leather, 83 × 71 × 63 cm
Unlimited production
Lent by Moroso, Italy

Princess chair, 2004 (plate 14 and page 28)
Antique chair, silk, embroidery, 88 × 50 × 47 cm
Unique
Lent by Tord Boontje, France

Petit Jardin chair, 2006 (plate 15)
Powder-coated laser-cut steel, 188 × 148 × 142 cm
Edition of 8
Lent by Tord Boontje, France

Fig Leaf wardrobe, 2008 (plate 16, cover and
pages 26–7)
Hand-painted enamelled copper leaves, lost
wax cast patinated bronze tree, cast iron
tracery support structure, hand-dyed and
woven silk *trompe l'oeil* base and back,
210 × 150 × 70 cm
Unlimited production run for Meta, no. 1
exhibited
Lent by Meta, London

Vincent Dubourg (b. 1977, France)
Napoléon à Trotinette console, 2007 (plate 27
and page 6)
Bronze and steel, 135 × 144 × 50 cm
Edition of 8
Lent by Carpenters Workshop Gallery, London

Patrik Fredrikson (b. 1968, Sweden)
Table #1, 2001 (plate 23)
Untreated birch, steel strap, 32 × 900 cm
Edition of 8 by Fredrikson Stallard for Editions
David Gill
Lent by Editions David Gill, London

Ineke Hans (b. 1966, the Netherlands)
Laser chair, 2002 (plate 30)
Laser cut MDF, 85.5 × 39 × 62.5 cm
Unlimited batched production
V&A: W.2–2006
Given by Ineke Hans

Tomáš Gabzdil Libertiny (b. 1979, Slovakia)
The Honeycomb Vase 'Made by Bees', 2006 (plate 28)
Wire frame, bees wax, variable dimensions
Edition of 7 (plus 2 artist proofs), artist proof
no. 2 exhibited
Lent by Studio Libertiny, the Netherlands

Julia Lohmann (b. 1977, West Germany)
'Else', *Cow* bench series, 2005 ('Anoushka'
illustrated plate 24)
Leather, upholstery foam, wood,
75 × 150 × 60 cm
Edition of 30, each unique
Lent by Julia Lohmann, London

Wieki Somers (b. 1976, the Netherlands)
Bathboat, 2005 (plate 31)
Oak and cedar, epoxy, 62 × 195 × 100 cm
Edition of 30 (plus one prototype)
Lent by Galerie Kreo, Paris

THE ENCHANTED CASTLE

Maarten Baas (b. 1978, the Netherlands)
Smoke mirror, 2007 (plate 33)
 Nineteenth-century French mirror, charred,
 188 × 120 cm
 Unique
 V&A: W.41—2008

Jurgen Bey (b. 1965, the Netherlands)
Tulip vase, 2008 (plate 55)
 Tin-glazed earthenware, 125 cm high
 Edition of 7, from the *Pyramids of Makkum*
 collection
 Lent by Royal Tichelaar Makkum, the
 Netherlands

Pixelated chair, 2008, (plate 47)
 Wood, embroidered felt, 92 × 64 × 55 cm
 Edition of 6, from the *Witness Flat* collection
 Lent by Studio Makkink & Bey, the
 Netherlands

Boym Partners (Constantin Boym, b. 1955,
Soviet Union; Laurene Leon Boym, b. 1964, USA)
Venus and Mars chair and mirror, 2006 (plate 50)
 Maple, mirrored glass, anonymous 1980s oil
 on canvas replica of Paolo Veronese's *Mars and
 Venus United by Love*, 1570s
 Chair 99 × 53 × 56 cm; mirror 120 × 97 × 4 cm
 Unique, from the *Ultimate Art Furniture*
 Collection
 Lent by Boym Partners, New York

Sebastian Brajkovic (b. 1975, the Netherlands)
Lathe chair VIII, 2008 (plate 40 and pages 58–9)
 Bronze with nitric-acid burned patina,
 embroidered fabric, 105 × 140 × 85 cm
 Edition of 8, no. 1 exhibited
 V&A: W.40—2008
 Purchased after a generous award from the
 Moët Hennessy-DesignArt London Prize

Matali Crasset (b. 1965, France)
Diamonds are a Girl's Best Friend 1 lantern, 2008
(plate 55)
 Paktong, mouth-blown sheet glass, 80 × 60 cm
 Unlimited production, first prototype
 exhibited
 Lent by Meta, London

Kiki van Eijk (b. 1978, the Netherlands)
Kiki carpet, 2001 (plate 38)
 Felted wool, 200 × 300 × 5 cm
 Edition of 20, no. 4 exhibited (the first with
 a black background)
 Lent by Kiki van Eijk, the Netherlands

Studio Job (Job Smeets, b. 1970, Belgium;
Nynke Tynagel, b. 1977, the Netherlands)
Robber Baron cabinet, 2006 (plate 36)
 Polished, patinated and gilded cast bronze,
 175 × 118 × 61 cm
 Edition of 5, artist proof exhibited
 Courtesy private collection, Prague

Robber Baron table, 2006 (plate 36)
 Polished, patinated and gilded cast bronze,
 76 × 183 × 91 cm
 Edition of 5, artist proof exhibited
 Courtesy private collection, Prague

Robber Baron mantel clock, 2006 (not illustrated)
 Polished, patinated and gilded cast bronze,
 mechanical clockwork, 107 × 66 × 50 cm
 Edition of 5, artist proof exhibited
 Courtesy private collection, Prague

Robber Baron standing lamp, 2006 (not illustrated)
 Polished, patinated and gilded cast bronze,
 glass, electrical components, 160 × 60 × 50 cm
 Edition of 5, artist proof exhibited
 Courtesy private collection, Prague

Robber Baron jewel safe, 2006 (not illustrated)
 Polished, patinated and gilded cast bronze,
 oil-based pigments, 122 × 50 × 50 cm
 Edition of 5, artist proof exhibited
 Courtesy private collection, Prague

Tulip vase, 2008 (plate 57)
 Tin-glazed earthenware, 147 cm high
 Edition of 7, from the *Pyramids of Makkum*
 collection
 Lent by Royal Tichelaar Makkum, the
 Netherlands

Hella Jongerius (b. 1963, the Netherlands)
Tulip vase, 2008 (plate 54)
 Tin-glazed earthenware
 Edition of 7, from the *Pyramids of Makkum*
 collection
 Lent by Royal Tichelaar Makkum, the
 Netherlands

Joris Laarman (b. 1979, the Netherlands)
Heatwave radiator, 2003 (plate 49)
 Reinforced concrete, 125 × 280 cm
 Prototype
 Lent by Joris Laarman, the Netherlands

Julian Mayor (b. 1976, Britain)
Clone chair, 2005 (plate 45)
 CNC-cut birch plywood, 95 × 50 × 59 cm
 Edition of 10 (plus five artist proofs)
 Lent by Julian Mayor, London

Gareth Neal (b. 1974, Britain)
George III chest of drawers, 2008 (not illustrated,
see plate 44)
 Oak, 109 × 51 × 82 cm
 Edition of 10, no. 5 exhibited
 Lent by Gareth Neal, London

Alexander van Slobbe (b. 1959, the Netherlands)
Tulip vase, 2008 (plate 56)
 Tin-glazed earthenware, 140 cm high
 Edition of 7, from the *Pyramids of Makkum*
 collection
 Lent by Royal Tichelaar Makkum, the
 Netherlands

Jeroen Verhoeven (b. 1976, the Netherlands)
Cinderella table, 2005 (plate 42)
 CNC-cut marble, 80.6 × 131.5 × 100 cm
 Unique
 Lent by Carpenters Workshop Gallery, London

Marcel Wanders (b. 1963, the Netherlands)
'Bella Bettina', *Bell* series, 2007 (plate 37)
 Hand-painted polyester, acrylic paint,
 176 × 150 cm
 Edition of 8 unique pieces, from the *Personal
 Editions* collection
 Lent by Marcel Wanders Studio, the
 Netherlands

HEAVEN AND HELL

Boym Partners (Constantin Boym, b. 1955, Soviet Union; Laurene Leon Boym, b. 1964, USA)
Buildings of Disaster, 1995–present (plates 1, 76 and 77)
Resin, variable dimensions
24 variants, each in an edition of 500
(Chernobyl; Texas School Book; WTC '93; Oklahoma City; Watergate; Unabomber's Cabin; Three Mile Island; Triangle Shirtwaist Co.; Waco, TX; Texas Bonfire Tower; O.J. Car Chase; WTC 9/11; Pentagon; Dakota; Alma Tunnel; Hands Of Victory; Empire State; Lorraine Hotel; Ford's Theatre; Superdome; Neverland; Golden Mosque; Greenwich Village Townhouse; Austin TX Tower)
Lent by Boym Partners, New York

Dunne & Raby (Anthony Dunne, b. 1964, Britain; Fiona Raby, b. 1963, Britain) **and Michael Anastassiades** (b.1967, Cyprus)
Hide Away furniture II, 2004 (plate 67)
Oak, felt
Unique object, one of three variants from the *Designs for Fragile Personalities in Anxious Times* collection
Lent by FRAC

'Priscilla, 37 kilotons Nevada 1957', huggable atomic mushroom series, 2004 (plate 70)
Reflective fabric, polyester stuffing, 27 × 30 cm
Edition of 20 each, in red and white, from the *Designs for Fragile Personalities in Anxious Times* collection
Lent by Dunne & Raby and Michael Anastassiades, London

'Seminole 13.7 kilotons, Enewetak Atoll 1956' huggable atomic mushroom series, 2004 (not illustrated)
Mohair, polyester stuffing, 40 × 114 cm
Unique prototype, from the *Designs for Fragile Personalities in Anxious Times* collection
Lent by Dunne & Raby and Michael Anastassiades, London

Niels van Eijk (b. 1970, the Netherlands) **and Miriam van der Lubbe** (b. 1972, the Netherlands)
Moulded Mole slippers, 2004 (plate 61)
Moleskin, 15 cm long
Unique, from the *Underdogma* collection
Lent by Studio Van Eijk & Van der Lubbe, the Netherlands

La Divina Commedia chair and lamp, 2008 (plates 73 and 74)
Polypropylene, laser-engraved and hand-carved decoration
Chair 90 × 50 × 70cm; lamp 60 × 60 × 235 cm
Edition of 5, no. 1 exhibited
Lent by Studio Van Eijk & Van der Lubbe, the Netherlands

Fredrikson Stallard (Patrik Fredrikson, b. 1968, Sweden; Ian Stallard, b. 1973, Britain)
The Lovers rug, 2005 (not illustrated)
Urethane, 245 × 119 cm
Edition of 8 (plus 2 artist proofs), prototype exhibited
Lent by Editions David Gill, London

Aluminium table, 2007 (plate 63 and pages 90–1)
Anodised aluminium, 32 × 120 × 76 cm
Edition of 8 (plus 2 artist proofs)
Lent by Editions David Gill, London

Rubber table, 2007 (not illustrated)
Polyurethane, 38 × 115 cm
Edition of 8 (plus 2 artist proofs)
Lent by Editions David Gill, London

Studio Job (Job Smeets, b. 1970, Belgium; Nynke Tynagel, b. 1977, the Netherlands)
Perished bench, 2006 (plate 60)
Laser-cut rosewood and bird's eye maple, 190 × 200 × 45 cm
Edition of 6
Lent by Studio Job, Belgium

Joep van Lieshout (b. 1963, the Netherlands)
Sensory Deprivation Skull, 2007 (plate 69)
Reinforced fibreglass, 137 × 150 × 110 cm
Edition of 10
Lent by Carpenters Workshop Gallery, London

Julia Lohmann (b. 1977, West Germany)
Lasting Void stool, 2007 (plate 59)
Fibreglass, resin, lacquer, 40 × 30 × 80 cm
Edition of 12 for Galerie Kreo, Paris
Lent by Julia Lohmann, London

Kelly McCallum (b. 1979, Canada)
Do You Hear What I Hear?, 2007 (page 92)
Nineteenth-century taxidermy fox, cast gold-plated maggots, 66 × 40 × 28 cm
Unique
Collection of R20th Century Gallery and Black Swan, NYC

Luc Merx (b. 1970, the Netherlands)
Damned.MGX chandelier, 2007 (plate 76)
Manufactured by MGX for Materialise, Belgium
Polyamide, 60.6 × 63 × 27.3 cm
Edition of 30, pre-production prototype exhibited
Lent by Materialise, Belgium

rAndom International (Stuart Wood, b. 1980, Britain; Florian Ortkrass, b. 1975, Germany; b. 1975, Germany)
Morse light MKII, 2009 (*Morse* light, 2006, illustrated plate 64)
Water, pigment, silicon, paraffin oil, glass, pump/valve system, rapid prototyped components, light source, laser-cut stainless steel, IC controller, custom software, 120 × 100 × 80 cm
Unique
Lent by rAndom International

Stephen Richards (b. 1964, Britain)
Storm chair, 2000 (plate 58)
Various timbers including ash, sycamore, walnut, oak and elm, 100 × 105 × 100 cm
Unique
V&A: W.1-2003
Given by Stephen Richards

Wieki Somers (b. 1976, the Netherlands)
High Tea Pot, 2003 (plate 66 and page 8)
Porcelain, water-rat fur, stainless steel, leather, 25 × 47 × 20 cm
Unlimited batch production
V&A

Maxim Velcovsky (b. 1976, Czech Republic) / Studio Qubus
Catastrophe vase, 2007 (plate 5)
Porcelain, natural and found materials, 37 × 20 cm
One of a collection of 12 unique vases
Lent by Mint, London

PICTURE CREDITS

All images are © V&A Images except:

Plates 1, 2, 50, 71 © Boym Partners
Plates 3, 4 © Hella Jongerius
Plate 5 © Maxim Velcovsky. Image courtesy of Mint, London
Plate 6 © The Artist. Courtesy of The Saatchi Gallery
Plates 7, 13, 15 © Studio Tord Boontje
Plate 8 Courtesy of Atelier Mendini
Plate 9 © Marc Newson. Courtesy of Gagosian Gallery
Plate 11 © Barnaby Barford. Image Theodore Cook/David Gill Galleries
Plate 12 © Blue Lantern Studio/Corbis
Plate 14 © Studio Tord Boontje Photograph Angela Moore
Plate 16 © Tord Boontje. Image courtesy of Meta
Plate 17 © V&A Images. The painting is at Apsley House, London
Plate 20 Courtesy of Shipley Art Gallery, Tyne & Wear Museums
Plates 21, 47 © Jurgen Bey (www.jurgenbey.nl). Photograph Studio Makkink & Bey
Plate 22 © Jurgen Bey, courtesy of Droog Design. Photograph Robaard/ Theuwkens (styling by Marjo Kranenborg, CMK)
Plates 23, 63 © Fredrikson Stallard, courtesy David Gill Galleries
Plate 24 © Julia Lohmann

Plates 25, 26 © Courtesy of Carpenters Workshop Gallery. Photograph Maarten van Houten
Plates 27, 40, 43, 69 Courtesy of Carpenters Workshop Gallery
Plate 28 © Tomáš Gabzdil Libertiny. Photograph Raoul Kramer
Plate 29 © The Artists
Plate 30 © The Artist. Photograph V&A Images
Plate 31 © Wieki Somers, courtesy of Galerie Kreo Paris. Photograph Elian Somers
Plate 33 © The Artist. Photograph V&A Images
Plates 34, 36 © Studio Job, courtesy of Moss New York, 2006
Plate 35 © By kind permission of the Trustees of the Wallace Collection, London.
Plate 37 © Marcel Wanders Studio (www.marcelwanders.com)
Plate 38 © The Artist
Plate 39 © Gijs Bakker. Photograph Rien Bazen
Plate 42 © The Artist. Photograph V&A Images
Plate 44 © The Artist
Plate 64 © The Artist
Plate 49 © Joris Laarman
Plate 51 © Richard Hutten
Plate 52 © The Artist, courtesy of Meta. Photograph Gianni Comunale & Paolo Pandullo
Plates 53, 54, 55, 56, 57 © Courtesy of Royal Tichelaar Makkum (www.tichelaar.nl). Photograph Studio Marten Aukes

Plate 59 © Julia Lohmann
Plate 60 © The Artists. Photograph Emilio Tremolada fotografo
Plate 61 © Niels van Eijk and Miriam van der Lubbe. Photograph Studio vier a/Peer van de Kruis
Plate 62 © Idiots. The National Museum of Art, Architecture and Design, Oslo. Photograph Karin Nussbaumer
Plate 64 © The Artists
Plate 65 © The Artist
Plate 66 © Wieki Somers. Courtesy of Ej kwakkel. Image Keramiekmuseum Princessehof, Leeuwarden. Photograph by Erik & Petra Hesmerg
Plate 67 © The Artists. Photograph Jason Evans
Plate 70 © The Artists. Photograph Francis Ware
Plate 72 © Jake and Dinos Chapman. Photograph Stephen White. Courtesy Jay Jopling/White Cube (London)
Plates 73, 74 © Niels van Eijk and Miriam van der Lubbe. Photograph Studio vier a/Peer van de Kruis
Plate 75 © Courtesy of the British Library
Plate 76 © The Artist
Plate 77 Alte Pinakothek, Munich / The Bridgeman Art Library
Plate 78 © The Artist. Materialise. MGX

INDEX